Willow Creek
HISTORY

Willow Creek HISTORY

TALES OF COW CAMPS, SHAKE MAKERS & BASKET WEAVERS

MARCIA PENNER FREEDMAN

Charleston London

THE
History
PRESS

Published by The History Press
Charleston, SC 29403
www.historypress.net

Copyright © 2013 by Marcia Penner Freedman
All rights reserved

Front cover, top: Courtesy of the Lowie Museum of Anthropology, University of California–
Berkeley. *Bottom*: Courtesy of the author.
Author photo by Gay Abarbanell.

First published 2013

Manufactured in the United States

ISBN 978.1.60949.644.9

Library of Congress CIP data applied for.

For Laila, Paolo and T. Violet Golde

Contents

Contents

List of Illustrations

Acknowledgements

I owe a debt of gratitude to a number of people who assisted me in the course of researching this book.

Adam Wallace at the Special Collection Research Center of the Henry Madden Library at Fresno State University made boxes and boxes of historical materials available to me week after week. Professional staff at the Bass Lake District of the Sierra National Forest provided me with maps and historical photos. They met individually with me and helped fill in the gaps of my knowledge of hydrology, archaeological sites in the forest, recreation and range management.

Others who were of great help were Connie Popelish and Ginny Smith of the North Fork History Group, Kay Good of the Coarsegold Historic Society, Mary Sholler of the California History and Family Research Room at the Madera County Public Library, Elisse Brown of the Sustainable Forests and Communities Collaborative and Jeannie Habben of the Central Sierra Watershed Committee. I thank also the family of June English and the staff members of the Oakhurst and North Fork public libraries, the Sierra Historic Sites Association and the California History and Genealogy Room at the main branch of the Fresno County Public Library.

The personal stories and comments quoted in this book are taken from interviews of local residents who kindly opened their homes to me—sometimes twice—or met with me in coffee shops and talked about their experiences, their work and their family background. In the aggregate, these people embody the complexity of the history surrounding Willow Creek. Other valuable sources for local stories were the Coarsegold Historic Society's publications, the volumes

of *As We Were Told*, and an interview conducted by June English, a historian with the Sierra National Forest during the mid-twentieth century.

A special thanks to Julie Elstner, editing goddess, and to Gay Abarbanell, Susanne Sommer, Elaine Russell, Andi and Paul Bergman, Sandra Alonso, Lise Rosenthal, Jean Phinney and Roger Mitchell, who each in his own way supported and assisted me.

To Marcie Miller, Susie Rappaport, Bob Whitley and Bayard Stone, with his amazing border collie—Star, the insatiable retriever and swimmer—our treks in search of the headwaters and confluences of Willow Creek will remain a precious memory for me. For that, I thank you.

To Bob Whitley, my hydroelectric guru, thank you for your staying power during my constant barrage of questions—sometimes the same ones over and over—as you helped me piece together my understanding of the intricacies of the PG&E hydroelectric system.

Finally, I'd like to thank Aubrie Koenig, editor at The History Press. Her patience and unperturbed guidance helped me navigate through some fairly sticky problems.

Introduction

My Willow Creek adventure started with apple picking. It was mid-October. I had told my friend Marcie that I was interested in hiking along Willow Creek up in the Sierra Forest. Marcie suggested apple picking instead. I wasn't sure what Willow Creek had to do with apple picking, but I went along with her idea. We drove up to a meadow she knew about where hundred-year-old apple trees still produced fruit.

We were alone. Marcie carried her collecting bag and went to pick apples. I stood holding mine and gazed out over the meadow. There was not a sound, except for the low-grade hum that seems to accompany complete silence in the wilderness. The blue sky was graying over, suggesting a possible early snowstorm. A single farewell-to-spring blossom, as if unaware that winter was on its way, blew among the dry grasses.

As I stood there, my mind began to wander. It occurred to me that Willow Creek, its water level low at this late-fall time, ran just beyond the ponderosas that edged the meadow in the far distance. A slight regret passed through me that we weren't hiking there at that moment. Then I took notice of the apple trees. Something about their gnarled toughness made me think about the life that must have been going on in this forest one hundred years ago in mid-October. I could visualize settlers harvesting the last of the fruit, ranchers driving their cattle down out of the mountains, loggers and miners closing up their camps for the winter. My mind went back hundreds of years when native tribes summered in this area. They would be packing up their villages now, preparing for their trip down to their winter homes in the foothills.

That was the beginning of my curiosity about Willow Creek beyond a place to hike. After that day, I wanted to learn as much as I could. I began to ask around. I approached people who lived and worked in the area, those whose families had been here for generations. I was certain they would share my enthusiasm and excitement about Willow Creek. I depended on them for information, to fill me in on my gaps in knowledge. After all, I was a relative newcomer to these parts, having arrived in the area just a few years before. They were long time residents, people with history and tradition behind them. Much to my surprise, their responses left me with more questions than answers:

> *Is this the same Willow Creek that goes into Bass Lake?*
> —local hiker
> *My grandmother lived near Manzanita Lake. Was that Willow Creek?*
> —Mono Indian basket weaver
> *That was Willow Creek? We just swam in it, just kids having a good time.*
> —third-generation logger
> *I spent years walking rivers and streams. Willow Creek was just another creek.*
> —retired Forest Service professional
> *What's so interesting about Willow Creek?*
> —resident of North Fork

That was the beginning of my discovery of Willow Creek.

Willow Creek is a strip of water that begins its journey high in the Sierra National Forest and ends—after a descent of seven thousand feet—at its confluence with the San Joaquin River, twenty-five miles downstream. For the past one hundred and fifty years, Willow Creek has been at the center of economic and cultural development in the foothills of the Sierra. Native tribes that inhabited the areas around Willow Creek for hundreds of years continue to reside in the vicinity of the creek. The Sierra National Forest had its beginnings around Willow Creek. For generations, ranchers have passed their herds by Willow Creek in their summer treks to the high country. In the 1850s, Willow Creek's waters became a coveted source of money and power for settlers and industrialists. Since that time Willow Creek has been diverted, siphoned and dammed in the service of the logging and hydroelectric industries.

In the first fifteen miles of its run to the San Joaquin, Willow Creek crashes through narrow granite canyons and meanders through serene mountain forests. One can find ditches and siphons, long ago grown over, that carried Willow Creek waters to three flumes that were among the longest and

most innovative in the world. Its waters contributed to the conveyance of rough-cut lumber down sixty miles of flume to a large mill that became the city of Madera in 1876. Logging railroads passed over Willow Creek and ran beside it. Only railroad grade roads exist now, reminders of that time. The four campgrounds along the Willow Creek path were at the center of the logging industry. Today these campgrounds provide opportunities for outdoor adventurers to explore and experience the wilderness and for people to escape the summer heat of the valley, swim in Willow Creek's pools or simply enjoy the serenity and peace of the forest.

At the end of the first leg of its journey, Willow Creek pours into Bass Lake, and it is there that it is transformed into the hard-working water of the PG&E hydroelectric system. Before joining the San Joaquin River, the waters of Willow Creek will pass through five power stations that generate twenty-seven megawatts of power for the state of California, provide recreation for visitors and local residents in a system of three lakes and contribute to the irrigation of the Central San Joaquin Valley, the richest agricultural area in the state.

The Willow Creek drainage, which is in the general shape of an oval, spans eighty thousand acres of forest, private land and small towns. In describing what a drainage is, hydrologist Andy Stone related it to a bowl with a spout at the bottom. "It's a catchment where water will preferentially run to the center of this low point," he said. "Nested within the Willow Creek watershed are thousands of smaller watersheds, all draining downstream into a big trough."

At the lower elevations, the creek passes through rolling hills flanked by high ridges to the east and west. White alder, ash and willow grow along its banks. In the higher regions of the watershed, Willow Creek travels through dense forests of ponderosa, sugar pine and white fir. Although its headwaters are believed to rise in the area of Iron Mountain at an altitude of over eight thousand feet, Stone explained that "it's difficult to name a true starting point for a particular drainage. Typically, it might be a culmination of fingers of streams and channels that eventually come together to form the headwaters."

Willow Creek was not always called Willow Creek. Newcomers to the area in the mid-1800s saw its confluence with the San Joaquin River and apparently made the assumption that it was a north fork of the river. That's what they called it: North Fork San Joaquin. They didn't consider that the creek that nurtured their orchards and gardens, watered their hogs and cattle and powered their lumber mills was a major tributary of the San Joaquin

River with a distinct point of origin and many feeder creeks, that the creek itself could even boast of having its own north and south forks.

It's not clear exactly when the name Willow Creek first appeared. Nor are the circumstances around the naming clear. On the Madera County maps of 1912 and 1919, Willow Creek is still referred to as North Fork San Joaquin. Interestingly, on the 1919 map, Chilkoot Creek is named Willow Creek. On the 1927 and 1934 maps of the Sierra National Forest, the section south of the confluence of the North Fork and South Fork is named Willow Creek. The United States Board on Geographic Names, in 1937, rejected the name North Fork San Joaquin River for the stream and its North Fork. Two Sierra National Forest documents of June 1937 officially designated the name Willow Creek to the part south of the junction of North Fork and South Fork Creeks and the name North Fork Willow Creek to the western stream of the two that unite to form Willow Creek.

To further complicate the matter, most of the significant historical events referred to in this narrative involve the North Fork Willow Creek, the section of the creek that runs from its headwaters high in the forest to the point at which it joins South Fork Willow Creek. Technically speaking, the actual Willow Creek is formed at the confluence of the North Fork and South Fork branches of the creek and flows six and a half miles from there to the San Joaquin River. For the purpose of simplicity, in this narrative the term Willow Creek is used as an umbrella term to refer to both North Fork Willow Creek and Willow Creek. In those instances when an event involves both the North Fork and South Fork creeks, the name North Fork Willow Creek is used to distinguish it from the South Fork Willow Creek.

So, in answer to the fellow who asked, what's so interesting about Willow Creek, it's everything, even the name.

For the person who sees Willow Creek as just another creek, perhaps this history will spark some new excitement. For those who know a little here and there about Willow Creek, this history can bring it all together. For those who are just discovering Willow Creek, walk the flumes, follow the ditches and penstocks that lead to the powerhouses, search the forest for siphons, ditches and remnants of loggers camps. Swim. Hike. Camp out.

And for the local hiker who asked if it is the same Willow Creek that goes into Bass Lake, the answer is, yes. It's all Willow Creek.

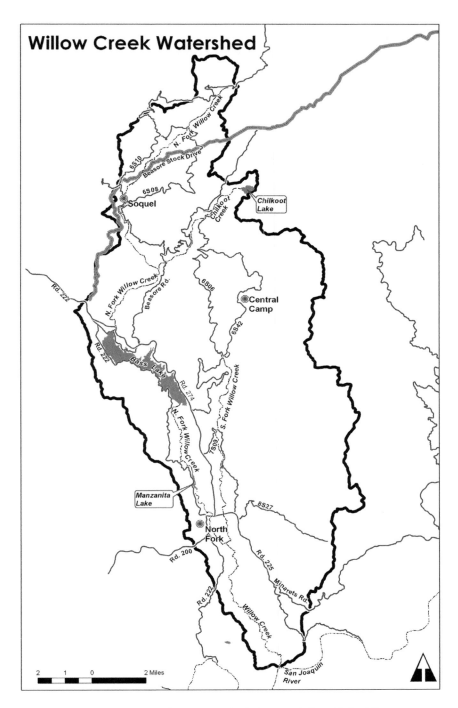

Map of the Willow Creek Watershed. *Courtesy of Sierra National Forest.*

Part One

CREEK WITH A PAST

Generation to Generation

THE NORTH FORK MONO

M ono Indians had lived in Crane Valley—present-day Bass Lake—for hundreds of years before the arrival of the white man in the mid-nineteenth century. Crane Valley is a strip of land several miles long and a mile wide, bordered on both sides by forests of pine and oak. Willow Creek runs through the middle of the valley on its way down from the high country to the San Joaquin River. The Mono divided their time between their summer homes high in the Sierra Nevadas and their low elevation winter homes, one of the places being Crane Valley.

At that time, the valley was a grassy expanse with no signs of the white man's settlements that would come. There were no lumber mills, homesteads, apple orchards or fenced-in cattle. No herds of hogs ran free to fatten up on acorns. It would be half a century before hydroelectricity and the dam that would inundate the valley, forming Bass Lake. In their interview for *As We Were Told,* Nellie Williams and Nokomis Turner, a Mono brother and sister whose ancestors lived in Crane Valley, said that the Mono were attracted to the area because of the abundant food sources, particularly the acorns, a staple in their diet.

Although it wasn't until 1851 that the Mono would be chased from their land, their destiny as a displaced people had its roots in events that took place during the half century before. With the move west of American settlers in the early nineteenth century and then the explosion of settlers entering California during the Gold Rush, the Mono found themselves competing with the white man for land they had inhabited for hundreds of years.

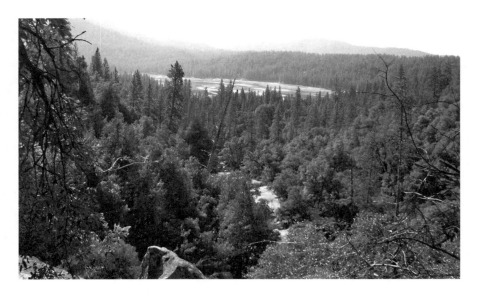

Crane Valley, with Willow Creek running through the middle, was surrounded by forests of sugar pine, ponderosa and oak. The native presence in Crane Valley has been traced back some ten thousand years. The whole surrounding area was a convergence spot for three tribal groups: to the north the Sierra Miwok, to the west the Chukchansi Yokut and right in Crane Valley, the Western Mono, the most recent inhabitants. *Courtesy of Marcia P. Freedman.*

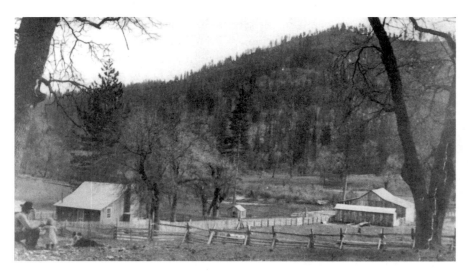

A serene scene of a settlement in Crane Valley circa 1860. A man and a child sit under a tree with a dog nearby. Three structures appear in the photo: a cabin, a barn and a doghouse. Willow Creek runs through the property at the edge of the meadow. Goat Mountain rises in the distance. *Courtesy of the Sierra National Forest.*

"History glorifies the first gold discovery by an American on January 24, 1848," wrote Gaylen Lee, in his book, *Walking Where We Lived: Memoirs of a Mono Indian Family*. Lee, a local fifth-generation Mono and chronicler of his family's history, contends that the arrival of the hordes of miners during the gold rush "unintentionally supported the federal government's quest for the western United States by inundating California with Americans." That is to say, expansionism was not new in 1849. The government had been pushing it for decades. The unofficial doctrine of Manifest Destiny, America's moral imperative to spread democracy throughout the land, had taken hold, remnants of which seem alive even today.

The origin for the term Manifest Destiny can be traced to an 1839 article, *The Great Nation of Futurity*, by John O'Sullivan, an influential political journalist:

> *In its magnificent domain of space and time the nation of many nations [America] is destined to manifest to mankind the excellence of divine principles…governed by God's natural and moral law of equality, the law of brotherhood—of "peace and good will amongst men."*

The concept gained further strength when President James Polk, without specifically embracing the terminology, supported the notion of coast-to-coast expansion in his inaugural address in 1844:

> *As our population has expanded the Union has been cemented and strengthened…It is confidently believed that our system may be safely extended to the utmost bounds of our territorial limits, and that as it shall be extended, the bonds of our Union, so far from being weakened, will become stronger.*

And then, in 1845, in his article *Annexation*, advocating for America to acquire Texas from Mexico, O'Sullivan coined the actual term:

> *It surely is to be found, found abundantly, in the manner in which other nations [England and France] have undertaken to intrude themselves… for the avowed object…of limiting our greatness and checking the fulfillment of our manifest destiny to overspread the continent allotted by Providence for the free development of our yearly multiplying millions.*

Imagine the pride and hope such ideas evoked in the citizens of a young nation founded on principles such as liberty and justice for all.

Driven by this expansionist culture and fueled by a sense of purpose and entitlement, settlers pushed into California in search of the promised wealth and good fortune.

In what might be viewed as a fast track move to shore up the aspirations of the settlers and to consolidate its hold on California after the signing of the 1848 Treaty of Hidalgo, which ended the war between the United States and Mexico, the federal government, between March 1849 and September 1850, took several actions. First, it established the Department of the Interior. It then transferred the Office of Indian Affairs to the newly created department from the Department of War—thus shifting the office's focus from trade and treaty relations to the disposition of land holdings. Finally, it established California as the thirty-first state of the Union.

As a consequence of the government's actions, a brutal war, the Mariposa Indian War (May 1850–June 1851), broke out between the native tribes and the settlers, mostly miners. The Mono fought. Although they were able to continue their life for decades after the end of the war, the traditional way of life of the Mono, in effect, ended in the spring of 1851 with the arrival of the Mariposa Battalion. This volunteer army of miners was commissioned by California governor John McDougal to drive the natives out of the forest. The battalion came through Crane Valley in their final push into the high country of the Southern Sierra Nevada to subdue Native American tribes on the run. One of the escaping tribes was the Mono.

In his diary, *The Mariposa Indian War 1850–1851*, Robert Eccelston described the valley as abundant in grasses and wild game, nearly covered with water, boggy and with a deep stream running through it lengthwise. The stream had no name at that time. It was referred to as a north fork of the San Joaquin River. Later it came to be known as Willow Creek.

To the battalion, the valley may have appeared uninhabited and for the taking. Upon entering, they all but declared it for themselves. They named it Crane Valley after a flock of birds that actually might have been great blue herons. They imagined harnessing the immense power of the springtime waterfalls pouring into the creek at the northeast end of the valley, possibly to turn mill wheels or to scoot lumber. Several of the men even claimed the area for a future ranch.

If they had observed more carefully, however, they might have noticed obsidian flakes on the ground or other signs of native activity. If they had ambled west a mile or so onto the granite outcropping in the forest above the valley, they would have found the telltale holes where the inhabitants milled their acorns. If they had been ordered to rendezvous with their scouts at the

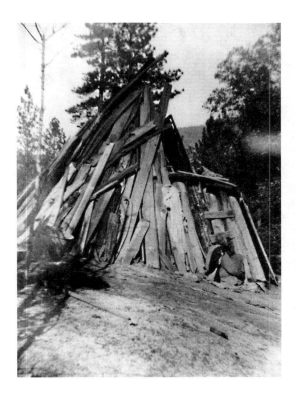

The Mono lived in conical-shaped structures called *tonobi*. They were made from the bark of cedar trees and could easily be dismantled for transport between the summer and winter homes of the Mono. Cedar bark was chosen for its capacity to defend against insect damage, its fire resistance and its insulating qualities. Tanned deerskin served as the doorway of the *tonobi*. *Courtesy of the Henry Madden Library at California State University Fresno.*

southern end of the valley instead of north at the double falls, perhaps they would have stumbled onto the cedar bark conical homes, *tonobi*, of the Mono ancestors of Gaylen Lee.

The leader of the battalion, Major James Savage, who was well versed in Native American culture and language, understood the signs. "Where you find game plenty," he is quoted by Dr. Lafayette Bunnell in his account of the Mariposa Indian War, *Discovery of the Yosemite*, "you will find Indians not far off." Savage pointed out the black oak acorns, roots and tubers, grasses and clover in the valley. "There is everything here for game animals and birds," Bunnell quotes him as saying, "as well as for the Indians." Yet even Savage, knowing that this land was home to Native Americans, remarked that it would be a "splendid place for a ranch."

Then in April of that year, the legislature of California wrote and passed the Act for the Government and Protection of Indians. Essentially, the law codified the white man's dominance over the native populations, in particular over Native American children.

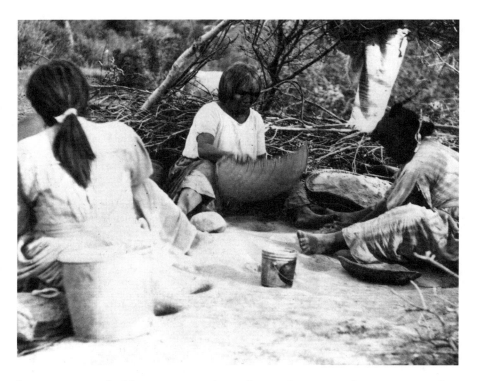

It was customary for Mono women to sit together outdoors processing acorns, a staple in the daily meals of the Mono of long ago. To knock the acorns from the trees, a pole made from a long willow or bull pine branch was used. Some Mono women still cook acorn in the traditional manner. *Courtesy of the Lowie Museum of Anthropology, University of California–Berkeley.*

It was in such a climate that the final months of the Mariposa Indian War took place in the Southern Sierra Nevada. For the white man, the war served to open up the territory to exploration and development. The settlers poured in. The Mono, in essence, became displaced persons subject to a powerful "civilizing" process aimed at absorbing them into white society.

Gaylen Lee's great-great-great-grandmother Chinitit, who Lee's Grandpa John remembered as "a little woman with white hair," lived during that violent time. Lee imagines her in springtime—before she and her descendants would be forced to adapt to a new way of life—sitting outdoors in front of her *tonobi* with other women, weaving and taking care of the children.

In California, the legal support for the assimilation process began with the Act for the Government and Protection of Indians (April 1850),

which, according to the California Research Bureau, "facilitated removing California Indians from their traditional lands, separating at least a generation of children and adults from their families, languages, and cultures (1850–65), and indenturing Native American children and adults to whites." The federal Code of Indian Offenses of 1882 strengthened the white man's legal rights, denying Native Americans use of their language and the right to conduct their rituals and traditional ceremonies. The code, which would remain law until 1933, virtually outlawed Native American culture. In 1887, the Dawes Act, a federal program that allotted forest lands to individual Native Americans, in effect broke up tribal governments and institutions and ended in the sale of large tracts of Native American land to non–Native Americans.

Thus, by the end of the nineteenth century, the Native Americans were separated from their ancestral lands and cut off from their traditional practices. They faced the challenge, which would last a hundred years, of maintaining their culture, even as they adapted to their new, sometimes unfathomable and, in many ways, incompatible reality.

For the Mono, cultural practices flow from connection to the land and to nature. Everything in nature is alive and has a spirit. The land is not owned or controlled but is respected and honored. In his article, *Gathering Philosophy,* Ron Goode, a Mono tribal leader, explains how this connection affects the day-to-day life of the Mono. For example, when gathering, whether for medicines, materials or food, they ask permission of the plants. Before climbing on a rock, they speak to it. Goode views nature's resources from the standpoint of their cultural value. "When I look at baywood," he writes, "I see bows, shelter covering and medicine…It's the same when I pick up a soapstone rock. Even before I rub the stone I've visualized an image, maybe a bear, eagle or snake. Whatever the image, I'll have connected with the stone's spirit and when my fingers run over the stone they're not touching a rock but instead feeling its inner spirit."

From generation to generation, the Mono have passed on their culture, sometimes through songs and stories, sometimes through trips into the forest. Gaylen Lee remembers learning from his grandma and grandpa. There was no physical classroom. Learning was everywhere, organic, went on as the family lived day to day. "I had no idea that I was being taught a unique lifestyle," he writes.

Ron Goode relates stories of walking in the fields and the forest with his mother, how she challenged him to hear the animals and insects and identify the different smells—grass, tarweed, clover and wormwood. They

touched things as they walked along, feeling the different textures, observing differences in each plant and animal track.

"The most important thing is for youth to learn their native culture, no matter how much life can get in your way," says Pauline Hazel Connor, a Mono, in *Landlessons.org, Native Voices*. Lois Connor, Pauline's daughter, is a master basket weaver who has absorbed her mother's passion for perpetuating Mono culture. "That's the driving force in my life," she explained, "to preserve the basketry, the spiritual beliefs, the traditional foods. I think it's very important for young people to know about their culture." Lois remembers her mother eating all the traditional foods, like meat bee larvae, rain bugs and caterpillars. She attributes her knowledge about their preparation, and her acquired taste for them, to her mother.

Pauline Hazel Conner was born in 1926, just two years after Native Americans were granted American citizenship. She lived with her family in South Fork until she was seven years old. Then they moved in with her grandmother and grandfather in the area of Manzanita Lake, where her mother had been born in 1906 in a cedar bark *tonobi*. Pauline's grandmother Lilly Bugg Harris, who was born in the 1860s after the Mariposa Indian War, was traditional, spoke the Mono language and wanted no part of the white man's world. When Pauline's father bought her a piano and Pauline began to play, Lilly Bugg disapproved and moved out to a small house next door. It was from Lilly Bugg that Pauline learned to speak Mono, to gather weaving materials and traditional foods and to make baskets. It took Pauline three months to finish her first basket. She was fourteen.

After Lilly Bugg died in 1942, Pauline became caught between the traditional ways of her grandmother and the tendency toward assimilation of her mother. Her mother forbade her to speak Mono and removed all baskets from the house. Lois knew they were hidden in a big old trunk in the closet. "I'd open this trunk and see all these beautiful baskets," she said, "and I'd say, 'Grandma why aren't we showing these?' 'Close that lid,' she'd say. 'Just leave it in there.'" Not until Lois was in late grammar school did her grandmother bring the baskets out.

Lois explained that her grandmother was terrified of the white man. She was just a baby when her sisters and brothers were farmed out to the boarding schools in Riverside and the Stewart School. They were taken, and the family was broken up. Lois believes her grandmother was protecting her daughters from having to go through the experience that her brothers and sisters went through. Even in the public school in North Fork where Pauline attended, they would wash out her mouth with soap if she tried to speak Mono.

Such fear and assimilation hampered the attempts to perpetuate the culture and created some temporary gaps in the generation-to-generation transfer, such as the one in Lois's family. But Lois's determination to learn basket weaving and speak the Mono language and Pauline's early training from Lilly Bugg helped them close the breach that had occurred in their family line.

Gaylen Lee writes that the culture will not be lost. The ancestors are always here. "By accepting the possibility of a relationship of all things to each other, there are no boundaries—everything is just the way it is. Just accept it. Don't ask why," he writes. His grandma's philosophy, *Aishupa*—"Don't worry. It's OK."

A CLOSER LOOK AT...

Basket Weaving

I know that nothing ends, all of life goes on, they [Grandma and Grandpa] *are still here, all of the old people are still here in other forms, continuing to teach us, if we will only listen.*

—Gaylen Lee

Basketry, in the Mono tradition, is more than simply producing baskets. In times past, basket making played an integral part in the daily life of the Mono family. The Mono woman, typically with children and grandchildren in tow, would venture out to her favorite gathering spots to cut the sticks and dig the roots that would go into her family's baskets. Ruby Pomona, Gaylen Lee's mother, has fond memories of walking in the Sierra Nevada with her grandmother, who taught her about the different materials she used to make her baskets, which, according to *Landlessons.org*, include redbud, sage and white root.

Gathering places exist throughout the Willow Creek watershed. Locally, people gather in the areas around Manzanita Lake and the north and south forks of Willow Creek. Lois Connor recalled gathering at South Fork Willow Creek, but she did not like it. "We dug on the south fork, my grandmother and her sisters' traditional digging place. We would go to South Fork and drive a little past," she recalled. "Then we'd turn on a dirt road and come back to the creek. That was the first place I learned to dig sedge root with Great Aunt Rosalie. One time, we were sitting there digging and she said, 'You know honey, don't get in the water.' I said, 'How come?' She said, 'It's polluted because of the [North Fork] Mill.' And I said, 'If this water is

polluted and we're going to put these roots in our mouths, why am I even digging them?' So we didn't go back there many times after that."

Not only did the Mono woman know how to gather, she also knew when to gather. She understood the elements and the land and knew such things as that the redbud stick is most pliable and the red color the deepest if cut during the coldest days of wintertime and that sourberry is good when cut in spring as well as winter. She had practical skill in how to keep the materials supple by burying them in the moist earth and how to seal water storage baskets with pitch from the bull pine. Bunnell, in his *Discovery of the Yosemite,* remarked that the Native American baskets used for boiling water were "strong as wire, and almost as durable." He was not able to identify the substance used to make them "wholly impervious," but described it as "a resinous compound resembling the vulcanized rubber used by dentists."

The spiritual life of the Mono finds expression in basket making, affecting when to weave, when not to weave and what designs to use. Gathering areas were considered sacred, not to be owned or controlled. They were protected by families from generation to generation. Lois Connor's grandmothers taught her about the spiritual connection to basket making. For Connor, it's everything. The plants have spirits. The animal spirits live in the designs. They draw the animal to you. "One of our traditions," Connor explains, "is you never work on a basket at night when evil spirits might be present. When the sun goes down, you put your basket away." Even today, one commonly finds a woman working on her basket straight through from sunup to sundown, then putting it away for the night and beginning again with the first light of the next day.

Rosalie taught Lois that a weaver has all the baskets inside herself waiting to come out. The basket maker might visualize the design in a dream then weave it into the basket as she works on it. Sometimes the spirit can take its time revealing what basket is ready to come out. Or, the weaver might have dreamed that she was supposed to make a basket with a big rattlesnake design on it, but then the spirit will change design right in the middle of her work. "It's like, I'll be weaving along and getting ready to start on the design," Connor says, "and I'll just feel the spirit say no, you've got to change and do this, and I'll say, ok. So you never know. I don't know why that is, but all I can do is follow it."

A family in those days might have had upward of ten baskets. But they were not displayed in cabinets for decoration or put on view behind hermetically sealed glass cases in museums. Each basket served a domestic purpose, to be

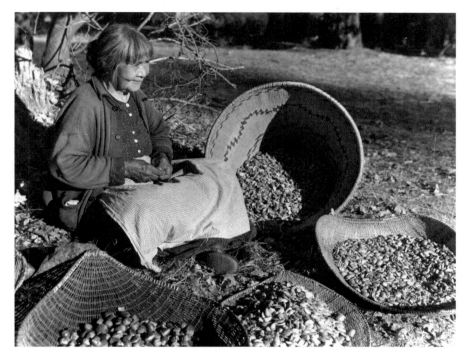

A Mono woman sits in front of baskets of acorns in various stages of processing, which involves shelling, winnowing (flipping and shaking the acorns to remove foreign matter), grinding into flour and leaching out the tannic acid with water. *Courtesy of the Lowie Museum of Anthropology, University of California–Berkeley.*

used during a ceremony, for games, holding trinkets or cooking. There were baskets for storage, gathering, sifting and beating seeds. The burden basket was for carrying loads.

One of the most identifiable and familiar of the Mono baskets is the baby carrier that was traditionally woven by the infant's paternal grandmother before the baby was born. The Mono baby basket functions like a combination of the infant sling and infant seat you see nowadays. It allows the mother to carry the baby snuggly on her back in addition to leaving it securely resting in sight while she goes about her daily chores.

Normally, girls learned to weave from their mothers and grandmothers or other women in their extended family. For some, basket making has become a lifelong pursuit. "At the time," Ruby Pomona recalls on *Landlessons.org*, "I was so young and wasn't interested in making baskets.

It wasn't until I was much older that I gained an appreciation for all my grandmother had taught me. I became a traditional basket weaver myself." Lois Connor knew from the time she was very young that she was meant to make baskets. She has spent her adult life immersed in learning traditional basketry. Now, she teaches young girls who may not have family members they can learn from.

Although traditionally baskets were made for home use, of late the Mono basket has become a sought-after item. Some weavers are willing to sell their baskets, but others are not. Norma Turner wouldn't think of selling her cooking baskets. She says on *Landlessons.org* that "they're a part of the family. They're just like one of the children. And these baskets are alive. That's what the old people always said. These baskets, just like the rocks, are alive...These materials that we make baskets with are alive...There's a connection between the ancestors, the people, the basket makers and these baskets."

Logging

A MOVING STORY

In 1854, two men, Charles P. Converse and Bill Chitister, purchased a lumber mill, dismantled it and moved it four miles to the base of Willow Creek falls where they had had their eye on a stand of pines in the adjacent forest. For three years, the men logged two hundred acres of trees—an area the size of two hundred football fields—using hatchets and handsaws to fell the trees. At their mill, oxen teams and two-wheel dollies hauled the logs and lumber to and from the mill. The power of the moving water from the falls ran an overshot up-and-down mill that sliced the logs into lumber.

Ponderosa and sugar pine have been known to grow to heights of over two hundred feet with trunks of thirty and forty inches around. Assuming Converse and Chitister avoided such giants, they were downing and limbing, nevertheless, some pretty large trees with their simple tools. The work was grueling and dreary, except, perhaps, for moments of excitement at the sight of the tree falling or the sound of the boom as it crashed to the ground. In summer, the heat had to have been insufferable at times. And the work was dangerous. "There are few implements [the axe]," wrote Stewart Edward White in 1911 in his book, *The Cabin*, "more satisfactory to handle well; and few more chancy, awkward and, yes, dangerous, to a greenhorn."

One wonders how Converse and Chitister picked up the skill and knowledge to run their business. Was it on-the-job training? White describes his own experience: "Perhaps you may find some woodsman miraculously endowed with powers of explanation who will tell you some of these things [technique for felling and cutting a tree]…But more likely you will have to try, and then figure a bit, and watch somebody, and figure a bit more, and

then try it again, until finally by dint of both thought and practice, you will arrive at skill."

Ardell Childers Ozuna, a Bass Lake resident and third-generation logger, explained that you have to learn to read a tree, see how it's leaning and plan where to put it down. "Trees have gotten away from people," she said. "But most of the time you just cut it and it goes down. For me, if it's out in the middle of nowhere where I can fell it, that's fine, but I'm not going to fell a tree that'll injure something. That's when I bring in the professionals." Converse and Chitister had few "professionals" to call on in the early days of the timber business. Theirs was more likely an on-the-job training experience.

In 1857, when they had logged out their section of forest, the mill was moved upstream from the falls, and for three more years, another two hundred acres were logged out. During this time, other mills popped up in Crane Valley along Willow Creek, and by the mid-1870s, hundreds of acres of forest had been logged out and millions of board feet of lumber cut.

Imagine the tumult. Do visitors to present-day Bass Lake know about the Crane Valley that once existed beneath their boats, floats and fishing lines? Can they conjure up the sound of one-hundred-foot ponderosas crashing to the ground? Surely the roar of motorboats and jet skis would seem like a cat's purr in comparison. And the campers and hikers who play amongst the trees, do they envision the forests denuded and chopped up? Are swimmers who leap from the rocks into the lake just below the falls able to imagine a saw slicing through a pine log five or six feet in diameter or oxen hauling logs from the forest on two-wheel dollies?

What of these early lumber mills? One might be tempted to dismiss them as quaint and relegate them to the backwaters of history. They were small and primitive. And, yes, the lumber they produced was purportedly not of the highest quality. But the miners and settlers had the lumber they needed. They built their sluice boxes and houses. They put up their fences. From these modest beginnings, over the next seventy-five years, logging around Crane Valley and Willow Creek would be at the center of innovation and growth of the Southern Sierra timber business.

At the heart of the industry was solving the problems of moving logs and lumber. In Crane Valley in the 1850s and '60s, the oxen were excruciatingly slow, their loads heavy beyond imagining. Several unoiled wagon roads reached Crane Valley at that time, and the Saw Mill Road between Crane Valley and Fort Miller (present-day Millerton) existed. But super highways they were not. The steep grade, winter snow in the foothills, overflowing

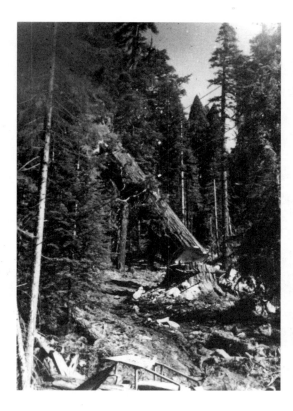

Felling the giant pines took great skill and was not without its dangers. *Courtesy of the Henry Madden Library at California State University Fresno.*

creeks from spring rains and snowmelt from the high country could be a source of woe for the oxen. In summer, dust, inches thick, caused wheels to bog down and axles to break. The recollections of an unnamed pioneer, reminiscing about his life in turn-of-the-century North Fork, described the situation: "The old teamsters risked their lives every time they brought their heavily laden wagons down the steep mountain grades."

Even in recent times, dust has been a problem for loggers. Danny Negrete, a North Fork resident who worked in the Sierra forest during the 1970s, talked about the effort it took to work in the heat and dust when conditions made it hard to move, to take a breath. Danny's wife, Jeanne, recalled his coming home covered in dust, his face caked with it, only a ring of bare skin visible around his eyes. When Negrete was assigned to drive the water truck, he was one happy man. Dust control was his favorite of all the jobs he had in his twenty years in the lumbering business. He'd go from forest pool to forest pool, filling his truck, and then would drive around, watering down the roads to make them passable for the loggers. It made things much easier and

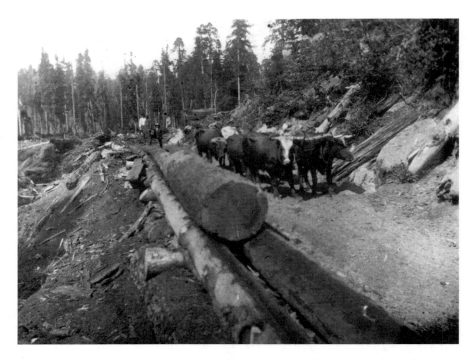

To build a two-pole chute, lumberjacks would lay long poles side by side in the semblance of a road. Lard, or whatever greasing material was available, was applied to the skids. The loggers would drive the team of oxen with their wagonload of logs to the edge of the chute. The logs would be rolled onto the poles and from there would be skidded along by the oxen. *Courtesy of the Henry Madden Library at California State University Fresno.*

safer. Unlike Negrete's job in the 1970s, in the mid-eighteenth century there were no water trucks. The dust presented a serious obstacle to the wheels and axels of the oxen-driven wagons.

Depending on oxen for moving logs presented its own set of problems, besides their slow pace. They needed to eat, and at times when grass was not available, mills had to close down. Bert Hurt, in his publication, *A Sawmill History of the Sierra National Forest, 1852–1940,* tells a story of a time when Converse and Chitister were forced to shut down their mill for lack of hay. Five Chinese miners who needed lumber for their sluice boxes came to the mill and found it shut down. They turned around, went into the forest, cut down the trees themselves and managed to get the logs to the mill by hand. "…And as fast as a board was cut," Hurt writes, "a man would shoulder it and start for the mines. The next morning sluice boxes were in operation in the camp fifteen miles away." Gold fever was still in

the air in the mid-1850s. Who knows what a pioneer with gold on his mind was capable of?

One of the first significant advancements in moving logs took place in Crane Valley in 1871 when partners George Sharpton and George Green built their steam-driven mill and a three-quarters-of-a-mile, two-pole chute to convey logs. Although primitive, the chute enhanced the efficiency in the Sharpton-Green operation. While at first they sold most of their wood to settlers in Crane Valley, Fresno Flats (present-day Oakhurst) and Coarsegold, as roads improved and the quality of their lumber increased, they were able to increase their service area. By the time they sold their mill in 1876, they were transporting good grade lumber cheaply and safely to the San Joaquin Valley, taking advantage of the markets there.

The pole chute Sharpton and Green built in Crane Valley represented the kind of innovation seen during the earliest years of the timber industry. Dulce Tully Rose, during one of her family's cattle drives to the Sierra in the early twentieth century when she was a child, recalled seeing skid roads in the forest. She described them in her interview in the Coarsegold Historical Society's oral history book, *As We Were Told*: "They were narrow…and the bulls would walk on the side of these skid roads and pull the big logs down to the mill." She said that every so often they would come across a big barrel full of what they believed was bear grease. The men would go ahead, and "it was one man's job to grease the logs," she said.

During this time, other things were happening that would completely change the logging business in the Sierra Forest. In 1873, the railroad was completed between San Francisco and Fresno. In 1874, the line was extended as far south as Bakersfield. As a result, many new markets opened up. Also, water, which was looking more and more like an answer to transporting timber, was becoming a commodity subject to ownership and rights.

Enter the big guns.

For industrialists and landowners in the San Joaquin Valley, Sierra logging was beginning to look like a pretty good bet. These "industrial cowboys," as author David Igler called them in his book *Industrial Cowboys: Miller and Lux and the Transformation of the Far West, 1850–1920*, would ride "roughshod over the region's terrains," generating conflicts and litigation over control of natural resources such as water and timber.

A particularly intriguing story about an industrial cowboy raid involving Willow Creek appears in *As We Were Told*. In the 1870s, a French company that invested in a quartz mine about fifteen miles from Crane Valley sent a man to oversee the building of the mine. It seems that the man had unlimited funds.

He certainly had big ideas. He proceeded to build a luxurious mining town called Narbo, replete with fine homes, a presidential mansion and one of the largest mining mills in the state. As part of his plan to run the mill, he decided to construct a canal that would bring water from Willow Creek. That's fifteen miles of flume. At the point when the mine was ready to become operative, the Miller and Lux Company, one of the largest landholders in the San Joaquin Valley, claimed the water rights on Willow Creek and forced the mine out of business. This may be one of the more colorful stories to come down through the years, but let's make no mistake: this was big business that involved foreign investment, grandiose schemes and fierce competitiveness.

The tapping of Willow Creek figured into another industrial scheme during this time that was to have far-reaching implications not only for the logging industry but also for irrigation in the San Joaquin Valley and the very founding of the city of Madera.

In the forest about ten miles above the falls, Willow Creek flows through an area that in the 1870s, encompassed the California Lumber Company, a large steam-powered mill on California Creek. The plan of the California Lumber Company was to build a flume to the San Joaquin Valley, some fifty miles away, that would bring its rough cut lumber to the site of the newly constructed railroad. There, it hoped to build a planing mill to finish and cut the lumber before shipping it out. The idea was perfect, or so it thought.

Its first move was to build a ditch that diverted water from Willow Creek, several miles away, to the Fresno River watershed to siphon water over to the flume when the Fresno River level was low. It worked for two years, using the lumber it had milled to build the flume and trestles. In order to reach its destination, the flume had to cross over mountains and canyons and had to bridge streams. Sometimes trestles sixty feet high were built. Imagine the feat of engineering and the courage and ingenuity of the men who hauled and hammered, climbed and balanced sixty feet above ground.

But after completing twenty-three miles of flume it was stopped dead, fifteen miles from its goal. Faced with having to pay a high price to cross through private property, the company abandoned construction and looked for another plan.

At the same time that the California Lumber Company was building its ditch and facing its crisis, Isaac Friedlander and William Chapman, industrial cowboys with large land holdings in the vicinity of present-day Madera, were building ditches of their own. Their interest was irrigation for agriculture, which was beginning to expand in the San Joaquin Valley.

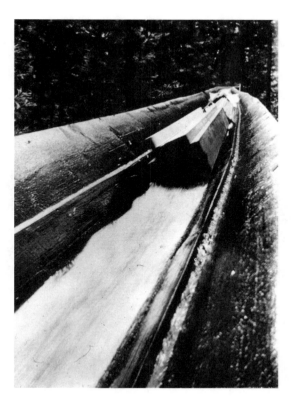

Raw cut lumber was scooted down flumes to the planing mill. Flume tenders kept watch to make sure the lumber traveled without hitches. Sometimes the tenders lived in cabins alongside the flume. *Courtesy of the Henry Madden Library at California State University Fresno.*

The plight of the California Lumber Company grabbed their attention. The two partners entered into a deal with the logging company. Friedlander and Chapman offered to rebuild and enlarge the diversion from Willow Creek. In turn, the California Lumber Company would have use of all the water it needed to run the flume, with the proviso that it give up all rights to both the Fresno River water and the Willow Creek ditch. When the lumber reached the end of the flume, the California Lumber Company would have relinquished all rights except for the lumber. Friedlander and Chapman could then direct the water to their irrigation ditches and canals. But that wasn't the end of it. Friedlander and Chandler agreed to donate a large portion of their own land to the California Lumber Company if the company would build its planing mill on it. At the completion of the mill, they called the site Madera, the Spanish word for wood.

But the fate of the California Lumber Company was not dependent on schemes and deals, not even on the founding of a city. The drought of 1876–77 dried up the creeks and rivers, causing a serious reduction in

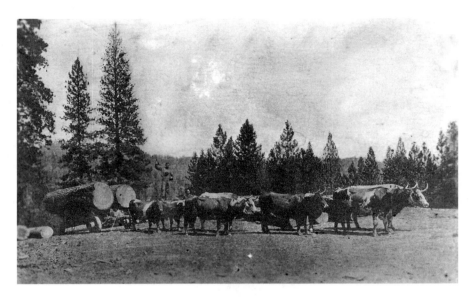

A team of eight oxen hauls giant logs at Soquel Meadow. *Courtesy of the California History and Family Research Room at the Madera County Public Library.*

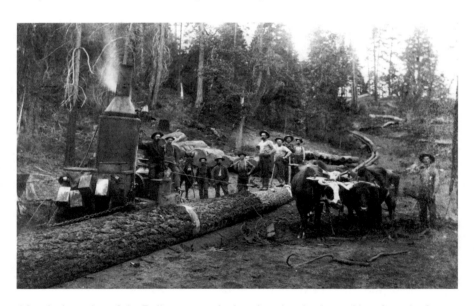

After the invention of the Dolbeer steam donkey, dragging the downed logs from the forest was accomplished mechanically by a cable attached to the donkey at one end and the logs at the other. The donkey could be moved from place to place to accommodate the loggers. In this photo, the logs are lying at the end of a two-pole chute. *Courtesy of the Henry Madden Library at California State University Fresno.*

the production of lumber. The California Lumber Company was forced to close down.

It wasn't until 1880 that investors in Sierra timber began to resurface. Twelve thousand acres of forest were purchased, and the California Lumber Company morphed into the Madera Flume and Trading Company. A thirteen-year period of prosperity would follow.

The new owners located their mill 2 miles upstream from the original California Lumber Company site to an area closer to the Willow Creek water. They built their new mill with equipment hauled by oxen over 150 miles of rugged terrain from a town called Soquel in Santa Cruz. The mill kept the name Soquel. The new owners also expanded and set up a second mill, located about 2 miles northwest of the Soquel mill, in the area of the giant sequoias at Nelder Creek.

Two major innovations in the Sierra took place during this time that changed how the mills operated. The first was the introduction of the Dolbeer spool donkey, a steam-driven device invented by naval engineer John Dolbeer. The donkey, essentially a stationary steam engine on a platform with ropes attached, was used to skid logs along the pole chutes from the forest to the mill. The spool donkey saved time and effort, spared the animals and men and sped up the production of lumber. Hank Johnston, in his *Thunder in the Mountains*, guessed that with the spool donkey more logs could be skidded in half an hour than ox power could achieve in half a day. "In a very few years," wrote Johnston, "Dolbeer's imaginative creation and others like it would end animal logging in the Sierra forever."

The second innovation occurred in 1889. When the forest near the Soquel mill was just about logged out, the Madera Flume and Trading Company built a four-mile, narrow gauge logging railroad, the first in the Sierra Forest. By this means, it could log farther into the forest without having to move the Soquel mill away from the Willow Creek waters. If you can't bring the mill to the forest, you bring the forest to the mill.

By 1892, the original twelve thousand acres were logged out, and the Soquel and Nelder Creek mills closed down. For seven years the milling operation languished. By 1899, everything was in rough condition. The mill at Nelder Creek was in ruins. The Soquel mill had been partially destroyed by fire. The flume was in poor condition. Bob Whitley, a former systems operator for Pacific Gas and Electric, said that the Soquel diversion still exists but is in a pretty bad state and grown over. It's hard to know when it was last used.

In 1899, the Madera Sugar Pine Company purchased what was left of the Madera Flume and Trading Company and moved everything to the

Lewis Creek area south of Yosemite National Park. There it constructed a large, modern sawmill and built the town of Sugar Pine, which is currently home to three thousand people. The mill would flourish for thirty-two years before closing down in 1932. Diane Bohna, a local rancher and cattle driver, said that her mother's father worked as a flume tender for the Madera Sugar Pine Company. When Bohna's mother was a girl, they lived on the flume for awhile. She recalled watching the logs floating down the flume, how her father had to make sure the logs kept flowing because if one stopped, it was trouble. The others would keep coming and pretty soon there'd be a logjam, and it would take out the whole flume. It was a dangerous job with great responsibility.

The history of the Madera Sugar Pine Company was one of expansion. Over its years of operation, the company acquired more and more timber and spread the railroad farther and farther into the forest. According to Allen Harder in *As We Were Told*, in 1921, the Madera Sugar Pine Company had expanded its holdings to fifty thousand acres. This covered nineteen air miles of forest that included the Greys Mountain area around Willow Creek. By 1927, the railroad had been extended to the site of the old Willow Creek siphon, where the Greys Mountain logging camp was located. The railroad line branched out for miles from the camp, crossing back and forth and running alongside Willow Creek.

The Greys Mountain camp was one of twenty auxiliary logging camps in the Madera Sugar Pine's system. There were also a number of distant camps. They all existed along the logging railroad lines or were connected to a railroad line by hoists when the terrain demanded. Access to water for the men and the animals was essential, so a creek was never far away.

The Greys Mountain camp was large, according to Ray Gallardo, a former National Forest summer ranger. There was housing for families. Children attended school nearby. The story goes that the apple orchard at Sivils ranch, just a few miles away, supplied the Greys Mountain camp with apple pies and cider.

But for the more remote camps, one pictures a primitive setting with few amenities besides a place to eat and a place to sleep. It's not likely, however, that the lumberjacks would readily succumb to isolation and a routine of backbreaking work, eating and sleeping without some form of amusement. Not surprisingly, there are stories about gambling and informal competitions like log rolling and speed riding over trestles that took place at these camps, which the present-day Loggers' Jamboree that takes place annually in North Fork mimics. In addition to games and fun, these camps doubtlessly had

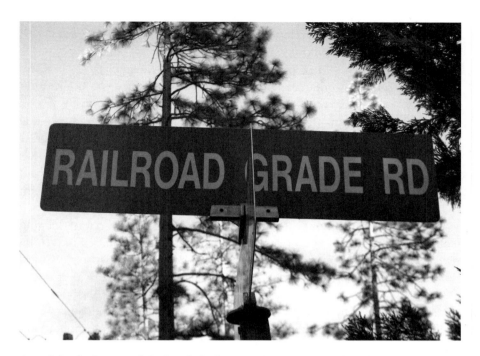

A road sign in the area of the Bass Lake Dam stands as reminder of the Sugar Pine Railroad, which ran from Central Camp, over the dam, and connected with the Minarets & Western Railroad in the town of Wishon. The road to present-day Central Camp was the main branch of the Sugar Pine Railroad. *Courtesy of Marcia P. Freedman.*

their supply of hard cider or corn liquor. After all, what's a guy to do on a long summer's evening when the day's work is done, the forest is still and the trains quiet?

In 1921, the officials of the Madera Sugar Pine Company founded the Sugar Pine Lumber Company, a completely separate entity. Harder suggests that the new company was formed to work the trees that the Madera Sugar Pine Company could not get to without overtaxing its operation.

The Sugar Pine Lumber Company functioned in two separate parts with distinct standard gauge railroad lines and headquarters for each branch. There was the Minarets & Western Railroad that served the area from Bass Lake south to the main headquarters at Pinedale some fifty miles away and the Sugar Pine Railroad that covered the area from Bass Lake twelve miles east to the forest headquarters of Central Camp. The switching place for the two railroads was at the town of Wishon on the west side of the Bass Lake dam. In order for the Sugar Pine Railroad to reach Wishon, tracks were laid over the dam.

Central Camp has been referred to as "the Hilton of logging camps," with all-electric, hotel-like buildings that housed several thousands of people, a large dining hall with fine food, a school and a medical facility.

Ardell Ozuna's grandfather Hank Childers worked as a crane operator at Central Camp. His main job was to move logs and lumber with his crane, but he spent much time righting trains that would commonly derail on some of the steep grades of the tracks. Ozuna's father, Warren Childers, grew up there. He described Central Camp as a good place to grow up. He tells stories of catching trout in Sand Creek, which ran through the camp, and how he lugged the fish to the trains coming in from the forest and sold them to the loggers with families at the camp.

But the mill lost money every year and, despite its modern logging techniques and up-to-date electric mill, it went bankrupt after only nine seasons. The operation was dismantled and the tracks pulled out. Today, railroad grade roads in the area of North Fork and Bass Lake are a reminder of those times, but very little else remains. Hank Johnston in his book, *The Whistles Blow No More*, writes, regarding the founding of the Sugar Pine Lumber Company, that "the last railroad logging operation to be built in the Southern Sierra was perhaps the most lamentable failure in the history of American lumbering."

Possibly because of its history of unfulfilled promise, Central Camp has gained a certain mystique. Today, when one drives up the road that was once the main railroad line between the camp and Bass Lake, the ghosts of the trains trail behind. You peer out into the canyon, and the vision of a one-hundred-foot train trestle dances dizzily in your mind. Twelve miles up the road, you drive over a sparkling creek and enter a village of rustic cabins, an isolated mountain retreat tucked away in the forest.

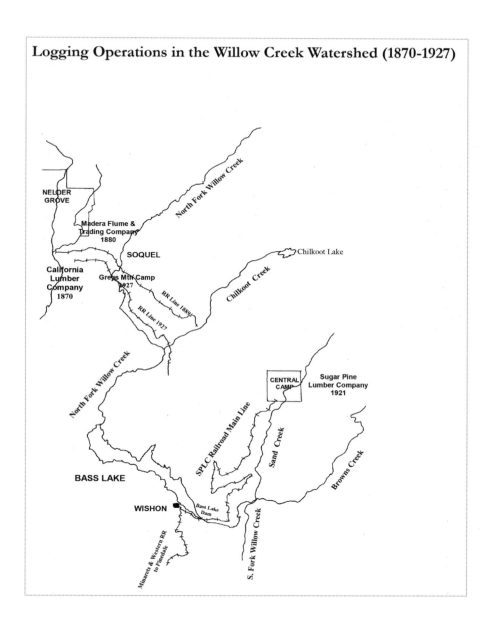

Logging Operations in the Willow Creek Watershed (1870-1927)

NELDER GROVE

North Fork Willow Creek

Madera Flume & Trading Company 1880

SOQUEL

Chilkoot Lake

California Lumber Company 1870

Greys Mtn Camp 1927

Chilkoot Creek

RR Line 1889

RR Line 1927

North Fork Willow Creek

CENTRAL CAMP

Sugar Pine Lumber Company 1921

SPLC Railroad Main Line

Sand Creek

Browns Creek

BASS LAKE

WISHON

Bass Lake Dam

Minarets & Western RR to Pinedale

S. Fork Willow Creek

Map of logging operations compiled and drawn by Marcia P. Freedman.

A Closer Look at...
Shake Makers

This picturesque clan of mountaineers [shake makers] *became, like Bedouin outlaws, proud of their isolation, and perfectly able to cut shakes on Government land when they chose, snake them out uncaught, and loaf the winter through on the proceeds.*

—Charles Howard Shinn

It seems that wood shakes have been a source of problems in California for a long time.

In 2012, there is a homeowner insurance problem that has been going on for over thirty years. Wood-shake roofs are considered a fire hazard, and therefore, it's not so easy to get homeowner's insurance for a house with a wood-shake roof. Insurance companies are known to deny an application outright. Or, they make it difficult for the homeowner to acquire the insurance, sometimes imposing a surcharge on the policy. In some cities, building a new house with a wood-shake roof is not permitted.

In 1905, when Charles H. Shinn became the first supervisor of the Sierra National Forest, the problem was the shake makers themselves. Shinn realized early on that he had inherited a legacy of animosity and antagonism toward the shake makers and was under pressure to give them the boot from the forest. "I think that for twenty or more years," Shinn wrote, "many influential people, and newspapers, have been opposed to the whole body of workers in this peculiar but perfectly legitimate local industry." Even the leadership in the government was against the shake makers. In 1902, when Shinn was head ranger of the Sierra National Reserve, which later became the Sierra National Forest,

he was told that the government would never approve the sale of timber to shake makers.

Whether this presented a challenge to a determined Shinn, or whether he simply understood the potential economic advantage of selling timber to shake makers, when he became superintendent, he set out on a quest to legitimize the industry.

Shinn admitted that he came to the Forest Reserve with a negative attitude. Shake makers were known to "cut as they pleased, felling tree after tree in total ignorance of scientific principles." Shinn understood that very few trees would cut into shakes and that a man had to learn how to test a tree before felling it. "The old pioneer way," he wrote, "was to cut a tree down, saw a piece off, and try it. One still finds logs of superb sugar-pines five or ten feet in diameter, which were cut and left by these earlier gypsies of the tree-killing trade."

So when "a little ineffective man, singularly elusive and silent" came to ask him if the government would sell him trees for making shakes, Shinn decided to go with the man to the shake camps to learn about them. What he discovered was that the man had improved his technique for testing a tree before felling it and that he offered to pay higher prices than the lumber mills. Shinn concluded he "was entitled in equity to a chance to live, and to support his family in his own way."

For three or four years Shinn devoted himself to getting to know about the men and their trade. He studied the sugar pine and the technique of shake making. He involved himself with the men and their families. He involved his rangers in studying "the shake problem at first hand—not from books and ancient prejudices." As he got to know them, Shinn developed warm and sympathetic feelings toward them. What he learned was that there were fifty "natural shake makers" in the area; that the shake maker had a specialized skill; that he loved his work, his camp life and his freedom; and that he was happy to "make a living out of a summer's work—and there ambition ceased."

Despite his growing fondness and respect for the shake makers, Shinn could not completely step out of his bias about their way of life. He reflected on the possibility that some of them would "branch out" and begin to expand their business and produce other useful items, such as posts and grape-stakes. He imagined that they could help the rangers from time to time and that "some of their children would make first-rate rangers."

Whether that ever came about is not clear. What did happen is that Shinn developed a plan that involved a section of timberland "so scattering,

rocky, and difficult of access, that lumbermen will not want it for years" and opened up a road to the timber to several shake makers, who built cabins and bought shakes from the government. Each man was assigned a section that was marked off and followed a detailed plan for cutting the shakes.

Shinn admitted that the plan would have to go through adjustments as the lumbermen and shake makers registered their complaints and discontents. But they went ahead with his plan, and by 1907, they were selling large amounts of shakes at good prices, a handy piece of timber management, you might say.

North Fork

NOT JUST A SPOT IN THE TRAIL

The town of North Fork is situated along Willow Creek, midway between Bass Lake and the creek's confluence with the San Joaquin River. Unlike Crane Valley, sought by settlers for its fertile land and miles of available creek, North Fork's relatively low elevation access to the high country, with the north and south forks of Willow Creek running side by side within a mile of each other, was what first put the area on the map.

Milton Brown, believed to be the first white man to settle in North Fork, built a cabin in the mid-1860s on the north fork of Willow Creek—known then as the north fork of the San Joaquin River. That the cabin sat at the end of a trail used by herders and miners passing through on their way to the high country apparently was not happenstance. Brown must have seen opportunity there. He stocked his cabin with supplies and opened a way station, spawning a small settlement called, variously, Brown's, Brown's Sawmill (Albert Brown, not Milton) and Brown's Place.

It appears that the industrial cowboys of the San Joaquin Valley showed little interest in developing the area around Brown's Place, even though the likes of the Miller and Lux Company—one of the industrial cowboys described previously—ran their herds of cattle and sheep through there to their summer encampments. Perhaps the industrialists were too involved in building flumes and planning their logging railroads to pay attention to what was happening in a tiny settlement. Perhaps with Willow Creek they had already tapped the most accessible major water source for their purposes. So by the mid-1880s, Brown's Place had attracted independent-minded pioneers who built family-owned

businesses, developed roads and contributed to the cultural life of the area, pioneers like the Peckinpahs.

Charles Peckinpah, in the mid-1880s, built a family-run lumber mill in the mountains east of Browns Place. "After building a road up the very steep mountain side," wrote Charles's son, David, in a 1934 letter to teacher and conservationist John F. Lewis, "machinery was hauled in and a mill employing from twenty to fifty men, depending upon the business transacted, was put into operation. Then came several uncles, big strapping men of the pioneer type, who located timber claims near and adjoining my dad's."

During this time, John Bartram and Albert Brown built a box factory and planing mill on the north fork of the Willow Creek in the area of Milton Brown's place. This also opened up a whole new area for work. The North Fork Lumber Company, as the mill was called, created a mini-town between the north and south forks of the creek, with bunkhouses, a forge, shops and a post office in one of the buildings. In a short time the settlement adopted its current name, North Fork, after the company's name. Roger and Loris Mitchell, in their book *Exploring the Sierra Vista National Scenic Byway,* wrote that the North Fork Lumber Company had political clout that influenced the Postal Service in their acceptance of the name.

The 1890s saw further expansion in North Fork: bridges over the north and south forks of Willow Creek, a second hotel, private homes and more opportunities for work. Lumber and stock had been the primary sources of jobs in North Fork until the last years of the decade when the fledgling San Joaquin Electric Company built a hydroelectric plant along Willow Creek several miles below North Fork, introducing a third important employer and bringing electricity to the town.

Another development took place in the 1890s, remote from North Fork, but which had major implications for its future. In 1891, the U.S. Congress passed the Forest Reserve Act, which opened up millions of acres of national forest to the stewardship of the government in Washington, D.C. The headquarters of the Sierra Reserve was situated in Fresno. A superintendent was assigned to oversee the three sections of the Reserve: Sierra North, Sierra South and Sierra East. In 1902, Charles Howard Shinn was named head ranger for Sierra North. "These head rangers," wrote Shinn's wife, Julia, "had to find their own quarters, provide their own horses, and stumble through the process of establishing a system for the California forests." Shinn chose North Fork as the headquarters of his reserve.

With Shinn and his wife came an environmentalist culture interested in the forest beyond its value as a source of income. In the midst of the

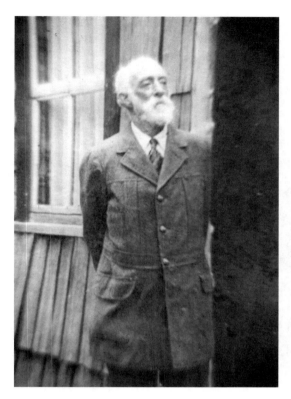

Charles Shinn was the first supervisor of the Sierra National Forest. In the beginning, and for several years, he and his wife, Julia, conducted Forest Service business out of their three-room cabin, which they called Peace Cabin. *Courtesy of the Henry Madden Library at California State University Fresno.*

antagonism and disillusionment of the area's stakeholders—the stockmen, lumbermen, miners, power companies—forest preservation, protection and management became part of the public dialogue. Then when the National Forest Service was established several years later, Shinn was named superintendent of the Sierra National Forest. Its headquarters was established in North Fork and would remain there until 1952. The North Fork History Group, in its DVD *The Way It Was (Vol. III)*, explained that North Fork was chosen as the headquarters because it sits close to the geographic center of the forest.

The Shinns' residence, a three-room cabin they named Peace Cabin, served as the first office. In 1911, the federal government acquired a parcel of land closer to the town of North Fork and built the new office building there. It was located on a knoll that would become the permanent site of the Forest Service headquarters. They called the building the Bridge Station because a bridge had to be built over North Fork Willow Creek in order to connect the headquarters with the town.

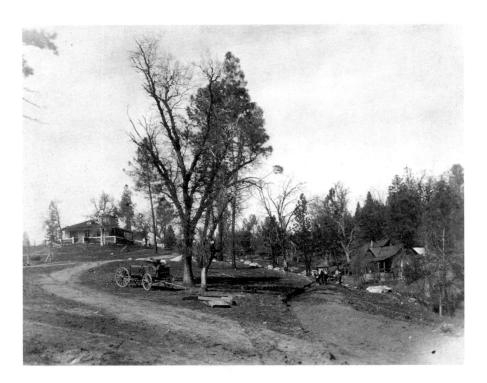

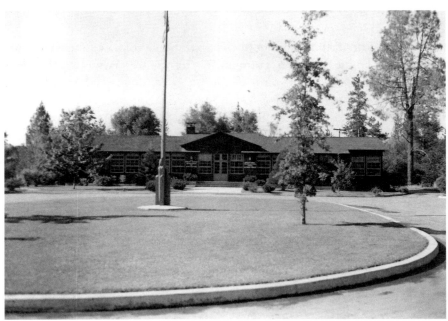

Above: The supervisor's headquarters, built in 1934, was located on the same knoll as the original building of 1911. Part of the original land acquired in 1911 came in a swap with a Mono Indian by the name of Chepo. The land he received in the exchange came to be known as Chepo Saddle. The photo is of the back of the Bridge Station headquarters. *Courtesy of the Sierra National Forest.*

Opposite, top: By 1911, the Forest Service had outgrown its offices. Charles Shinn acquired land close to the town of North Fork to build a new headquarters. The new compound was called the Bridge Station after the bridge constructed over Willow Creek that connected the site with North Fork. The new supervisor's headquarters shown in the photo was located on a knoll just north of the town. *Courtesy of the Sierra National Forest.*

Opposite, bottom: The expanded supervisor's offices were completed in 1934. When the headquarters of the Sierra National Forest was moved from North Fork to Fresno in 1952, the Bridge Station became the district headquarters and remains so to this day. The building seen in this photo burned down in 1992, and the present-day building, which preserved the general design, was constructed at the same location. *Courtesy of the Sierra National Forest.*

This was the atmosphere shortly after the turn of the century when Charles Peckinpah and his wife, Belle, moved down from the mountain and built a home in South Fork, a little community that had developed just east of North Fork, on the South Fork Willow Creek. Little by little they added rooms for rent and then a store nearby with an upstairs dance hall. "By that time the mill had been sold," reminisced Julia Shinn in a letter to her friend, "Mr. Peckinpah devoted himself to the store, and Mrs. P. to the home and

dining-room. You see, the teamsters ate there, on their way up and down, to and from the mill with their twelve to sixteen mule teams. Also there was always a supper after the Saturday night dance in Peckinpah hall."

The dances put on by the Peckinpahs were popular. Often Charles played the violin, and Belle played the piano to accompany the dancers. In his book *The Cabin*, Stewart Edward White portrays Charles Peckinpah as a fiddler who played "jiggy, foot-tapping things."

"The quadrilles are especially grand," wrote White, "for then the musician, both eyes closed, calls out. Each remark is jerked out with an accompanying strong sweep of the bow and swaying of the body. It is all about 'honey!' 'Pig'n a corn!' 'Po-liteness!' 'Swing 'round,' 'Go down, Moses!' "Coon up a plum tree!' and various inarticulate but inspiring sounds."

Julia Shinn described the dances at South Fork as "teetotal," in contrast to the dances at the dance hall in the town of North Fork, which were "opposite a saloon and within half a block of another," implying, obviously, that the North Fork dances were not "teetotal." Shinn claims that the Forest Service people and the Powerhouse people went to the South Fork dances. But one could imagine that the Forest Service People and Powerhouse people might also have enjoyed the North Fork scene as well.

Gene Rose, in his 1994 book *Sierra Centennial*, described turn-of-the-century North Fork as a small community, little more than a spot in the trail, with a couple stores and hotels. But the stories of people like Julia Shinn and Stewart Edward White give a different impression. Also, the recollections of an unnamed pioneer in a 1948 article in the *Madera Daily News* about North Fork depicted a self-determined, bustling, economically sound community where "pack animals and saddle horses were an everyday sight," "Peckinpah's mill high on the ridge east of North Fork was running full blast" and "ten and twelve-animal teams were continually on the narrow dirt road, hauling the high-piled loads of lumber to the San Joaquin Valley." From the pioneer's description, one conjures up an image of a colorful mix of people going about their daily business: homesteaders, families, business-minded folk, Forest Service people, transient miners and cattlemen, even vagrants. "North Fork saw its share of drifting men in its early days," the pioneer recollected. "A six-gun dangling from the hip was a familiar sight."

In addition to this dynamic, self-assertive community, the pioneer described another group of people he observed, one robbed of self-determination and autonomy. The Mono, who had fled into the forest after the Mariposa Indian War of 1851, had begun drifting back to North Fork, which previously had been their home for hundreds of years. What they encountered on their return was hostility, fear and a society bent on stripping them of their culture

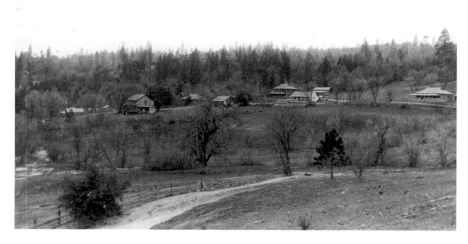

North Fork, circa 1910. *Courtesy of the Sierra National Forest.*

and educating them in the white man's ways. Their children were taken from them and sent to boarding schools. Gaylen Lee's grandma attended the Presbyterian Mission School in North Fork. "She never forgot the day the missionaries came to her parents' home at *Peyakinu* [the site of the family's home] and took her away," Lee wrote. "Her parents could do nothing to prevent their firstborn child from leaving. Tears flowed." Besides the threat of being taken away to the schools, young Native American daughters were vulnerable to arranged marriages to "squaw men" for dowry. Fear of the white man became strong among the North Fork Mono. The pioneer described his observation of Native American women and girls, "catching sight of a stranger or a white man they feared coming along the trail, [and taking] to the bush like scared rabbits."

As far as opportunities for work, the North Fork Mono had no social status. Their way of life was seen as primitive and their skills devalued. They were not trained for most skilled jobs and were virtually barred from working in places like the new power company. The Native Americans could only obtain low-paying menial jobs. Sometimes families were forced to become itinerant, working in the agricultural fields that were flourishing up and down the San Joaquin Valley.

With the destruction of the communal life that had sustained them for thousands of years and with virtually no property rights and little land ownership—or ownership of undesirable or useless land—homelessness and

drunkenness became rampant. Violence, disease and death followed. "The mournful cries of kindred constantly echoed through the hills," recalled the pioneer, possibly referring to the four-night *ana yagan* mourning ceremony of singing and dancing and free-flowing tears practiced by the Mono at that time.

Some of the entries in the diary of pioneer Joe Kinsman give a sense for the dismal circumstances of the Native Americans:

July 2: The Indians commenced to gathering into the cove to have a mourning feast over their dead.

July 9: Indians finished up crying and burnt the things belonging to the dead.

Jan 4: about 4 p.m. an Indian come into camp and said two squaws slept out in the snow and froze to death about one mile from Brown's store.

Jan 6: heard of two Indians found up a tree hung by the neck. They're good Indians now.

Apr 16: At the North Fork found an Indian snake bit his arm swollen very bad. I put on some tobacco, saleratus [sodium or potassium bicarbonate—a.k.a. baking soda] *and salt, then went to Brown's for dinner.*

July 25: two Indians shot.

Aug 26: about midnight heard some squaws and bucks screaming and making a hell of a noise on the other side of the river. I expect an over dose of bad whiskey.

That was over one hundred years ago. Today, after a century of struggle, the North Fork Mono has established a robust presence in the North Fork community. Their work reflects a range of activities geared toward the education and betterment of tribal members, as well as of members of the broader North Fork community. In addition to their social programs, the North Fork Mono's skill and knowledge on the management of the forest and native plants has become valued among Forest Service personnel and environmentally conscious people. The Mono Museum, situated between the north and south forks of Willow Creek has evolved into a significant cultural institution. Mono basket

weaving is taught at the museum and has become a respected and sought-after art.

Even the *ana yagan* death ceremony has seeped into the present-day North Fork consciousness in the guise of the annual cultural affair called powwow, or Indian Affairs Day. Gaylen Lee, whose family still conducts traditional *ana yagan* mourning ceremonies, denies the connection between the two traditions, tracing the roots of powwow to the history of the Plains Indians. But Lois Connor, Mono basket weaver, has noticed that if you tell some of the elders that you're going to powwow, they might ask who died. Perhaps the traditional dancing and singing during powwow is a thread that ties it to the ancient ritual.

It seems that present-day North Fork has its own connection to the past that sets it apart as a community. The diversity, independent spirit and entrepreneurship that characterize the town today have their roots in North Fork's beginnings. The Sierra Forest Service culture remains at the core of the community with the offices of the local district housed alongside Willow Creek.

Gay Abarbanell, longtime North Fork resident, artist and photographer, is struck by the unusual communal interdependence among the self-reliant, independent-minded people who are attracted to North Fork. "You could be busy every day with a different event," she said, "that brings together all the different groups that make up the North Fork family."

A Closer Look at...
Pioneers of a Different Sort

Pioneer: One who ventures into unknown or unclaimed territory to settle. One who opens up new areas of thought, research, or development.

—Webster's Online Dictionary

She Ventured into Her Job as Supervisor's Wife Toting Her Typewriter

Julia Tyler Shinn was the wife of Charles Howard Shinn, the first supervisor of the Sierra National Forest. She also worked as his clerk for several years as a volunteer and then as a paid employee. At her husband's retirement in 1911, Julia Shinn continued in her paid clerk's position until her resignation in 1923.

After Julia Shinn's death in 1956, at age eighty-eight, Gene Tully, pioneer ranger and friend of the Shinns, reminisced about her early clerking days: "The office was one typewriter, which Mrs. Shinn brought with her; her filing cases consisted of several small boxes, secured from the local grocery store, that fitted nicely under her bed…She tackled that uncompensated office clerk job, apparently as cheerful as if she had moved into a modern office."

But Julia Shinn's legacy went far beyond her formal status of wife and clerk. She was remembered for her quarter-century service to the forest and her unique quality of quiet leadership. Accolades came from those who knew

Julia Shinn, wife of Charles Shinn. *Courtesy of the Henry Madden Library at California State University Fresno.*

and worked with her: Sierra National Forest supervisor Maurice Benedict, Ranger Gene Tully, environmentalist and conservation professor John Lewis and many others. To them, she was the life of the community, a remarkable woman, a wonderful woman, the wellspring of the "Sierra Spirit," a grand lady, a valiant woman of high intelligence, the Mother of the Forest. By all accounts, Julia Shinn was every one of these.

She was also a gifted writer and storyteller with a natural wit and sharp eye for detail. Her letters and her articles, in such publications as *American Forests* and the *Sierra Ranger*—where she was listed as an associate editor in 1916—chronicle the early years of the Sierra Forest Service in North Fork. "Life was simple and hard in the hills," she wrote. The concept of forest management was new and the idea of conservation just beginning to take hold. The notion that the forests were there for all to enjoy and not just for the economic gain of an entrenched few did not sit well with the miners, lumbermen, cattlemen and homesteaders who had taken over the forest. That they polluted the streams and laid waste to the trees, that they claimed large tracts of virgin forest land as their own and that their cattle and sheep denuded the meadows were abuses that seemed overshadowed by

the settlers' belief in their right—their destiny—to exploit the forest for their own betterment.

In a letter written several years before her death to her friend Grace Tompkins Sargent, Shinn wrote:

> *We were the first to try to stop indiscriminate use of the forests—a use for pasture, for fence-posts, even for lumber, which the settlers had taken for granted were "anybody's." The mountain people were simple, friendly folk, urging us to stop for dinner, if we came along near noon, but hotly argumentative on the question of restricted use of the forest area. It took years for them to learn that the national forests belonged to the nation, not just to the neighbors. [But] you will remember that almost all the older people among the Israelites died off during their forty years in the desert, and that it was virtually a new generation that finally entered Canaan. Much the same thing had to happen to the people of the foothills before government regulation was accepted.*

Appeasing the resentment of the settlers was only one of many challenges faced by the early Sierra Forest managers. Negotiating the vagaries of the bureaucracy in Washington, D.C., was another. If they found the contact annoying or off-putting or if tension existed with the head office, one does not glean that from Shinn's writings. For example, when Washington turned down a request for good firefighting tools because "records showed the Sierra to have sufficient tools," she wrote, "We laughed and made or bought our own tools." When a month-end report of timber permits granted for cedars was "scathingly criticized" because Washington's records showed there could be no cedars left, Shinn recalled in her letter, "We laughed until we cried, for we knew there were oodles of cedar trees there. There still are—marvelous ones that gleam red when the last sunbeams shine through the boles of the tree on a late August afternoon."

From time to time, a hint of irritation bleeds through in her writing. About government inspections, for example, she recalled, "occasionally an inspector thought his whole duty consisted in finding fault. Him we endured, trying our best to do things his way thereafter. But people who understood helped us immensely and taught us a lot." Even in apparent frustration with the disconnect she felt between the Washington office and the reality of the Sierra Forest, Shinn was good-natured. "We could even see that Washington thought it was right," she offered, "but what would you? Washington was a long way from Northfork." With the establishment of the district office in

San Francisco, Shinn "drew a deep breath" because "a personal visit was not impossible, and facts could be explained *viva voce* that never could be made clear with a typewriter."

In addition to immersing herself in the official business of running the Sierra Forest Service, Shinn also engaged in what she referred to as her "self-assigned supervisorial roles." It might have been that these contributed equally to the smooth running of the service and, quite possibly, ultimately ensured its success.

For the Forest Service families, for example, she cultivated a social, intellectual and spiritual environment. In her 1930 article in *American Forests* she wrote:

> *One big advantage was time. Winter evening time, I mean, for, of course, summers were one long tense strain of fire, without roads, trails, telephones, lookouts or maps. But winter evenings—why that winter of 1902 we read Gibbons Decline and Fall, the whole ten or twelve volumes. By the next winter we had [Gifford] Pinchot's Primer of Forestry and Roth's first book, and we'd had a summer in the forests that gave us a basis for study of forest botany and forestry practice. We even had time to read poetry and essays and religion, and to begin to acquire the Saturday Evening Post habit that has since become so nearly universal in the Service. Religion really meant something when we read sermons because we wanted to…As the sense of permanence in the Service grew, books were accumulated in the camps and circulated from cabin to cabin, making many an evening delightful.*

Besides building community among the rangers and their families, Shinn seemed to understand that the service could not succeed without acceptance from the disparate groups in North Fork. She socialized with people from the sawmills, the power company, the Indian Mission school, stockmen. She forged mutually beneficial relations with the Native Americans:

> *The women would bring us their baskets to take care of while they went to the San Joaquin Valley to pick grapes; they would invite us to name their babies and to do errands in town. What had all this to do with the forests? A lot, for it was the Indians on whose labor we depended for fire-fighting, and it was mighty good forest policy to have them for our friends—aside from the plain humanity of it all.*

In those early days, Julia Shinn might have been viewed as a feminist. Not in the break-the-glass-ceiling sense of the word, but in the sense of her advocating for recognition of the Forest Service woman as a full partner with her ranger husband in the successful performance of his duties. In the men-only world of the Forest Service, this was a radical notion. Shinn argued that the forest woman could make or break her ranger husband's career. "In the forest the wife is part of the game," she wrote, "for no woman can live happily away from all other interests if the one vital interest in her husband's life has no value to her. A discontented wife inevitably forces a ranger's resignation."

In her 1930 article, she summed it up when she said that "as a group, the early forest women were a mighty fine lot and did their large share to start the system that has developed into the great Forest Service of today."

But the comment of Sierra Forest Supervisor Maurice Benedict, who served from 1916–44, presents a different view of Julia Shinn's legacy. In a letter to John Lewis in 1951, Benedict wrote, "In my opinion Mrs. Shinn deserves more credit than Mr. Shinn for the work done during that early period, and most certainly for the high sense of public responsibility imbued on the young foresters of that day, and I am proud to say that the Sierra still has that spirit. She is a wonderful woman and I shall always cherish her unselfish public service."

NORTH FORK HAD A MILL THAT RAN ON BRIGHT IDEAS

Many years after the giant lumber mills had closed their doors in the 1930s and after the industrial cowboys had dismantled their flumes and trestles, driven the last of their trains and trucks out of the forest, packed up and headed back to their offices, North Fork was going strong as the hub of the lumber industry in the Sierra foothills.

At the center of North Fork's logging activity was the mill, which opened in the early '40s under the name Associated Lumber and Box Company. For fifty years the mill—which changed names a number of times over the course of its existence—was the largest employer in North Fork and contributed substantially to the town's strong economy at that time.

Danny Negrete, a longtime North Fork resident, started working at the mill in 1974 after he and his wife, Jeanne, moved up from Long Beach.

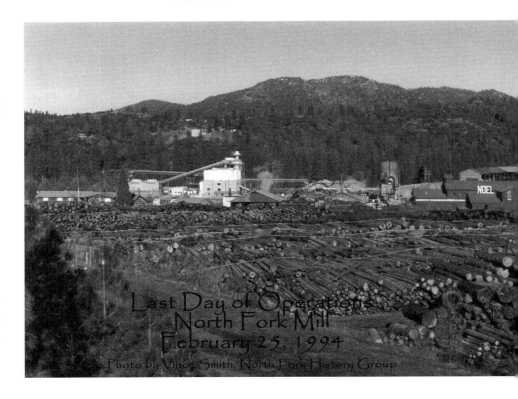

Last Day of Operations
North Fork Mill
February 25, 1994
Photo by Vince Smith, North Fork History Group

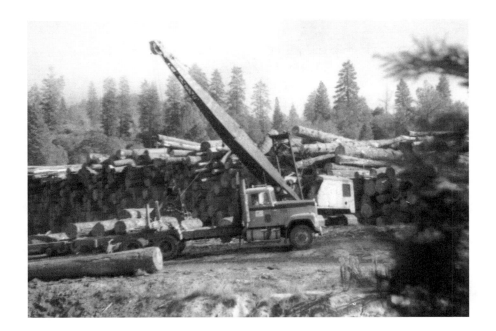

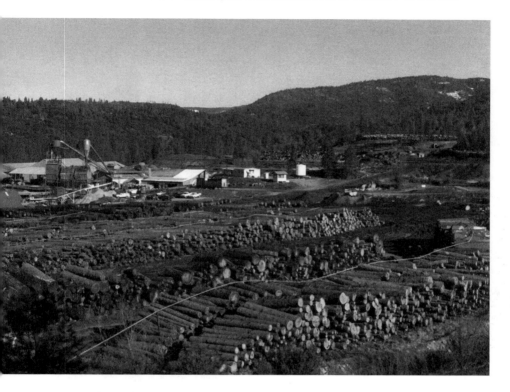

Above: The North Fork Mill on the last day of operation. February 25, 1994. Photo by Vince Smith. *Courtesy of the North Fork History Group.*

Opposite, left: Loading lumber at the North Fork Mill. Photo taken through the window of the mill office. *Courtesy of Danny and Jeanne Negrete.*

He worked there continuously for twenty years until the mill closed. When thinking back on having landed the job, Negrete sees it as a real stroke of luck. "It was July, mid-season," explained Negrete, "they didn't need anyone." Then someone at the mill broke a leg, and that was it. Negrete was hired. "They said they needed a knot bumper," he said, "I said sure, but I didn't even know what a knot bumper was. I was really green." Negrete was assigned to a crew, and when he went to join them, he found out that they had already chosen their own knot bumper. The supervisor told their man to go home, and Negrete took his place among them. "They didn't like me," he said and explained why:

> *I was a greenhorn from the city, happy just to be working. It was really something. There I was, having a good time on my first day of work, and*

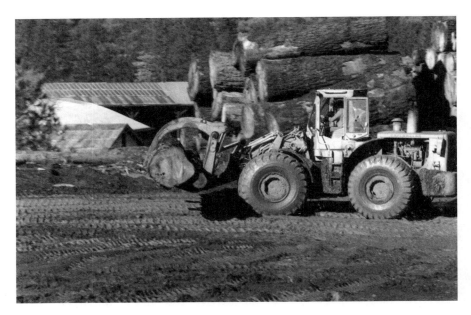

Front-loading log mover at the North Fork Mill. *Courtesy of the North Fork History Group.*

Residential camp for single workers at the North Fork Mill. *Courtesy of the Sierra National Forest.*

these guys hat[ed] my guts. I know all of them now, and we're old friends, mostly. They were really tough on me, though. Wouldn't talk to me. Ran over my chain saw. I didn't know how to run a saw, and nobody would show me. Then after a couple of weeks, one man started talking to me, then another, then we started going for beers after work. They finally accepted me—most of them.

For independent loggers like Warren Childers, and later his daughter, Ardell Ozuna, and his son Clark Childers, the mill served as both employer and outlet for their timber. Warren Childers owned a Michigan—a front-end loader—which he ran in the forest while he did his own logging. The mill hired him to unload the logs from the logging trucks and stack them into piles or to feed the mill when it needed more logs for milling. It was one of the first loaders of its kind to be used at the mill.

Childers's granddaughter Janette, who drove a logging truck for the mill, painted a picture from a black-and-white photo of her grandfather operating the Michigan. She gave it to him for a Christmas present. "He really liked it," she said.

Ardell and her brother started logging in the '80s. "My brother was working for the mill at the time," said Ozuna, a third-generation logger, "so it was convenient." Childers and Ozuna went into business with a two-and-half-ton truck they owned, a small rented loader and a lot of drive and enthusiasm. "I was pretty old when I started, but I really liked doing it," said Ozuna. "My brother would go out and fall a bunch of trees, and I would load them on the truck. Then we'd go to the mill, unload and do it all over again." Eventually they both built their homes from the lumber they logged. Ozuna ended up working at the log deck during the last year of the mill's operation; she drove a water truck.

Even to people in North Fork with no formal connection to the mill, its presence in the town has left a lasting impression. Don Trower, who has lived his whole life in North Fork, remembers the mill as an important part of the town. "It was the smell, the trucks, just part of it up here. You saw it all the time." Trower recalled school field trips to the mill and his visit to the mill's residential compound, which he described as a clean, nice little place with green lawns, everything in good repair and the houses with perfect, well-painted fences. According to Trower, "The mill is what kept the community together."

It seems that the mill has carried a certain mystique about it, aside from its having been so integral to the North Fork community. It was an innovative

Above: A typical kitchen in a mill employee home. *Courtesy of the Sierra National Forest.*

Opposite, top: The housing compound for married employees of the North Fork Mill was located just across the highway from the mill. *Courtesy of the Sierra National Forest.*

Opposite, bottom: A living room in the home of a North Fork Mill employee. Notice the fine wood paneling and flooring. *Courtesy of the Sierra National Forest.*

operation that utilized non-wasteful practices in its everyday operation. The lumber it produced came from the best logs whereas scrap material supplied the chips used for making particle board. The mill was powered by steam until the 1980s when a cogeneration plant was built. Then it was powered by electricity. Wood byproducts fueled the boilers of the co-gen plant. Power not consumed by the mill was sold to public utilities.

Cogeneration of electric and thermal energy had taken a roller coaster ride in federal regulation from the time of Thomas Edison's cogeneration plant in Manhattan in the 1880s, the first one in modern times. Over the years, energy recycling had fallen in and out of favor as the federal government responded to the changing conditions of industry, the environment and

energy sources. But after the passage of the Public Utility Regulatory Policies Act (PURPA) in 1978, which eased restrictions that were put in place earlier in the twentieth century, the mill at North Fork was able to catch an upward swing in cogeneration regulation. The co-gen plant at the mill came on-line in 1986 and functioned until its closing in 1994.

Anyone you talk to about the mill, sooner or later, will come to mention the co-gen plant.

It's been almost twenty years since the mill closed. Many ideas have been tossed around since that time about how to develop the 135-acre site, many of them geared toward things like attracting tourists or bringing in investors for outside businesses.

Community-minded North Fork, however, had its own vision. In June 1994, just four months after the mill's closing, a group of citizens got together and formed the North Fork Community Development Council (CDC), a nonprofit organization aimed at promoting the social, economic and environmental welfare of North Fork. Its main goal: to develop the mill site not as a tourist attraction or as a place for outside businesses but as an ecologically healthy environment with facilities that serve the community of North Fork.

Between its inception in 1994 and 2008, the North Fork CDC was able to renovate the old mill office, make its home there along with several other civic organizations in town, receive the title of the site from Madera County and achieve a major demolition and cleanup. Presently, the mill houses a lumber recycling business, the CDC itself, the Greater North Fork Art Gallery and a metal waste recycling company. Future plans include the construction of the North Fork Fire Station and a Mono tribal retirement home.

Then there are plans for developing a woody biomass power facility on the premises that would generate up to fifty megawatts of electricity to be sold to local electric companies. Once again the future of the mill, and in some ways the North Fork community, would be tied to the surrounding forest, the natural resource that supported North Fork for over a hundred years. This time, though, it wouldn't be about logging as in the settler days (that's handled by the Forest Service now); it would be about removing brush—overgrown after generations of fire suppression management—and other forest biomass materials that contribute to the danger of large, out-of-control fires. It would be about improving overall forest health and encouraging local residents to bring their yard cuttings to the facility, much the same as their taking a Saturday morning trip to the recycling center. It would be about being a model of community renewal for

other towns in the Sierra Forest that have suffered the effects of mill closures. It would be about innovation and originality, the same as so much of the history of the town of North Fork.

Generation to Generation

Imagine that it's 1912 in Coarsegold, California. It's the first day of school after summer vacation. The children are given an assignment to write a composition on how they spent their two-month summer break. Nine-year-old Dulce Tully describes a cattle drive to the mountains, her family's cabin, wandering around on horseback, fishing, picking strawberries and work, work, work. It's likely that some of Dulce's classmates would have written similar stories.

Including children on cattle drives goes back to the very earliest days of ranching in the Sierra foothills. In his book *Miners, Lumberjacks and Cowboys*, Dwight Barnes, a local journalist, writes that "over the past century and a half, ranching has been a tradition passed down through four and five generations." A tradition and a lifestyle, with its cattle drive, and children right there in the middle of it all.

Dulce Tully Rose was the daughter of Gene Tully, the first range manager of the Sierra National Forest. She was also the stepdaughter of Jerry Brown, grandson to Jeremiah Brown, who is credited with having trailed the first cattle to the Sierra foothills in 1853. From a young age, Dulce accompanied her family on their annual cattle drives to their permit area in the National Forest.

In the early days of cattle driving, families tended to travel together, helping each other out and sharing resources where needed. Each family packed in supplies to last their two-month stay in the mountains. Presumably, people brought personal items as well, some books, a diary, a deck of cards. Historian June English, in her 1979 interview with Dulce Tully Rose, asked what she brought with her. "Oh, I took a Teddy bear," Dulce said, "he rode

up in my bed [roll]. A couple of times we took dolls when we were tiny," she said. "For years, we took a cat. We would put him in a barley sack and cut a hole in it for his head to stick out and tied it on top of the pack."

Dulce's family partnered with two other families. Here is how it worked: At the beginning of the summer the three families would trail their cattle from their home ranches. They would congregate at a corral set aside at Crane Valley by the Forest Service. (The Bass Lake area was still called by that name in those days. Even today you might hear an old-timer refer to it as Crane Valley.) From there they drove their combined herds to the mountains. Then they separated their stock and spent the summer on their individual permits. When it was time to come out of the forest in the fall, the families brought their herds together in a gathering field and reversed their trek back to Crane Valley. There they drove the cattle into a holding meadow, sorted them and returned to their home ranches. The sorting took about a week, a week of cowboys pushing the horses in among the throng of cattle—there might have been as many as a thousand cows—kicking up dust, cutting out their herds and driving them to the corral. One wonders what Dulce was doing while all this was going on. Not sitting on the fence watching, for sure. She had to have had some job to do. All the children probably did.

In her later years, Dulce looked back on her summer treks to the mountains with fondness and nostalgia. But she was actually living through turbulent times in the history of ranching in the Sierra foothills, a history that reached back to the decades after the gold rush when the entitlement culture of the pioneer prevailed.

During those earliest times, cattlemen were unrestrained by regulation. They moved their herds to their summer pastures at will. They set up cow camps. They fenced fields, built cabins and spent the summer months grazing their cattle in the forest. It wouldn't be too much of a stretch to imagine them moving their animals from meadow to meadow in search of the prime pastures and ample water. It is easy to picture them bringing as many cows as they could handle.

But all that was to change. With the establishment of the Sierra Forest Reserve in 1893 and, subsequently, the Sierra National Forest in 1905, came a system of allotments and permits that restricted the ranchers in their use of the forest. Not surprisingly, this did not sit well with those independent-minded cattlemen who knew their business and rejected any intrusion into their lives and livelihood. It was a contentious situation. Stockmen had come to believe that they had vested rights in the public forests.

The trouble started immediately when initial consideration for issuing permits was given to the homesteaders adjacent to the forest. According to Julia Shinn, this brought about bitterness, particularly from big cattlemen like Miller and Lux. In a letter she wrote in the mid-1950s to a friend, she reminisced that "it took years to persuade [the ranchers] that the forests belonged to all Americans, not just to them. Big herders resented this and simply did not propose to stand for it. Many a day our little front room [of the Forest Service headquarters] was full of arguing cattlemen."

Gene Tully, as the range manager, had a difficult job. In addition to issuing the permits, he had the job of overseeing usage on the allotments. Gene Rose, in his book *Sierra Centennial*, wrote that Tully had to patrol six hundred miles of forest, a trip that took six weeks on horseback. Tully described the job as "a hard, lonely and sometimes dangerous life. Sudden illness, a fall, weather, slides and the threatened vengeance of a resentful stockman made the early rangers always watchful."

By mid-twentieth century, the allotment system had normalized, and permit holders were driving their cattle free from fear of other stockmen. At that time, communal drives still existed, a practice that served the family of Patrick Kennedy after the death of his father in 1943. Today, for the handful of individual families that still drive their cattle, it has become a solo endeavor.

Patrick was twelve when his father died. He and his sister, Maggie, had been participating in the family's cattle drives from the time they were little. So when their mother decided to continue ranching and making the summer trips to their permit in the mountains, they were ready. In his 1985 interview for *As We Were Told*, Patrick said that it was easy on horseback for three of them to handle a hundred cows. "We had cows that made the trip lots of times," he recalled, "they knew where they were going and would take right out for the hills."

The two main high country allotments within the Willow Creek watershed are Soquel and Central Camp. The typical route was from the Crane Valley corral (at Bass Lake) to Soquel Meadow and then on to the permit areas. On their way to Soquel, the herds passed over Willow Creek at the bridge near the Greys Mountain Campground.

Bart Topping, a third-generation rancher and cattle driver who participated as a youngster in his family's cattle drives, trails his cattle each year from the Crane Valley corral. Bart and Cindy Topping's daughter and grandchildren have become part of their family's cattle drives every summer. The route they take is the route that the Kennedy family took in the 1940s and the same one Dulce's family followed in the early part of the twentieth

Bart and Cindy Topping's grandson, Tyler, joins his family on its annual cattle drive to the high country. For five generations, Topping children have participated in this family tradition. *Courtesy of Marcia P. Freedman.*

century. In the early days, the Crane Valley corral was a hub for herders on their way to and from the high country. But these days, Topping is the only one who uses it.

For the Kennedy family, the trip to the permit area took three days from their property west of present-day Yosemite Lakes Park, which is just south of Coarsegold. The first two days were spent trailing to the Crane Valley corral where they joined two other families, stayed overnight to rest and the next day traveled together up to the Soquel allotment. Patrick remembered the second day of their drive as the most difficult, principally because they had to take a circuitous route to avoid State Highway 41 as much as possible. "The macadam oil and base on the road wears [the cows'] feet, and they get sore-footed," he explained. "It's natural for cattle to walk on dirt, so we would go the dirt way over Thornbury Road."

While the oiled highway symbolized growth and development for the area, for ranchers it presented a financial challenge that some could not

meet. It began in 1930, when Road 41, then a county road, was designated as a state highway. Over the next eight years, section by section, the road was developed—and oiled—between Coarsegold and Yosemite National Park. Because the oil on the road harmed the cows' feet, ranchers were compelled to truck their cattle to Bass Lake in order to access the dirt roads from there into the mountains. That expense forced some ranchers out of business.

But Patrick, Maggie and their mother persevered. With assistance from Patrick's uncle, Tom, and the two families they trailed with, they were able to continue ranching and trailing their cows until the end of the 1940s when they sold their herd and purchased a café and bar, which they ran for ten years.

Patrick said he considered the period of his life when he joined his family's cattle drives as golden years. He loved arriving at their cabin and turning the cattle and horses loose in the beautiful meadows at Soquel. "I suppose I would have been considered a cowboy then," Patrick said, "now you have a whole different breed of cattle people: you have rodeo cowboys and ropers, and people who don't move very many cattle out in the wild. They move a lot of cattle in the arena, and they are very good ropers—better than we were in the old days."

It is hard to know whether Patrick's statement was a wish for the good old days, a disapproving remark about the frivolity of rodeo or an appreciation of the skill of the rodeo cowboy. Perhaps all three. If anything, it seems he was commenting on the changes happening in the lifestyle of the foothill rancher.

According to the second volume of *As We Were Told*, rodeo has been present in Coarsegold since the day of the pioneers. In the early days, rodeos were actually working round-ups at which "a lot of encircling took place as cattle were gathered in the spring of the year for counting, branding and sorting." Possibly some informal competition arose among the cattlemen during these early rodeos, such as who could ride, rope or brand the fastest. But it wasn't until the mid-1920s that rodeo was put on for entertainment. By 1985, when Patrick was interviewed for *As We Were Told*, rodeo in Coarsegold had evolved into a major annual event of competition and entertainment that continues to the present day (its only hiatus during World War II).

Like the cattle drive, rodeo became, for some, a family affair, as with, for example, the Bohna family. Henry Bohna, a third-generation rancher, built the Coarsegold Arena on his ranch after the original site was sold. He involved his children—Cindy, Diane and Tom—in every aspect of the rodeo. They organized and set up for the events and pitched in with whatever was needed. Diane Bohna told *SierraStar.com* in a 2011 article that "from

carrying the flag in the grand entry, running the bucking stock through the chutes, doing grunt work, and even sometimes competing in the festivities we, the Bohnas, somehow became a rodeo family." That is to say, the family tradition of ranching for the Bohnas came to include the rodeo in addition to raising stock and herding cattle. To this day, Tom's love is the rodeo.

For Diane and Cindy, their focus has remained on raising and driving stock. Both sisters remember their first cattle drives in the 1960s, when they were barely out of their toddler years. That was before their dad brought them along on the mountain drives. On those early trips he drove the herd south to harvested hay fields where the cows grazed on the stubble that remained.

"It was hot," Diane recalled.

> We would start out probably about four p.m. and drive the cattle into the night. Dad would usually choose a full moon. I remember driving the cattle along, and it's surprising how the reflection off the drive made it illuminate and it would be like daylight. The only thing that made your hair curl I suppose is when you would hear a rattle snake, pddddd—and the cattle would just spread. And you never got off your horse, ever, when it was dark. I asked my dad what to do and he just said, don't ride over there. And I said ok. So I would just ride and we would go on.

Diane was seven years old the first time she went on her father's drive to the mountains. By eight, she knew she wanted to manage her own cattle ranch, to summer in the Sierras and winter in the foothills. Today, she runs her ranch and trails her herds to the mountains every summer.

Hers is a four-day drive. Her father's was seven days. "What I do now is like a powder puff," she said. "What Dad did was really, really hard. On the way in, we had to cross the San Joaquin River in heavy snowmelt. We had six hundred head, and it would take a whole day to swim each animal across."

Crossing the San Joaquin was a part of the drive for Adele Bissett Bartholomew's family as well. Adele rode on their cattle drives from an early age up until she went to college. Adele's job was ordinarily to act as the sweep, keeping the herd moving from the rear. Sometimes, when the water was reasonably calm, crossing the river was easy. "Once our cattle knew where they were going," Adele said, "and the summer pastures were so nice, with a lot of feed up there, the older cows just leapt into the river and swam." Sometimes the crossing would require a little ingenuity, especially for the calves and the cows that hadn't been there before and were a little leery about crossing. Adele's dad devised a shield that he

strung across the river to keep the inexperienced stock from looking upstream at the riverbank and turning back.

There were times when things were difficult and dangerous. In 1957, the river was very high, and Adele's father made the decision to send the supplies, the dogs and the crew across in a Southern California Edison cable car that was used for stream gauging. He was the only one who remained to drive the herd across. On the opposite side of the river, cowboys stood with ropes and tried to lasso the cows that got caught in the current. Some were rescued, but others didn't make it. That year they lost twelve or so calves down the river and several cows.

Adele remembers enjoying the drives. It was a family thing. Everyone took part. After she went to college, she spent her summers working in Yosemite. "It was the first time I had spent my summer in a social setting," she said. "I didn't go back to herding after that until I was already a teacher, and then, only for a short time."

The social setting Adele talked about was living and working among her peers in the bustling Yosemite National Park. The social setting for the cattle drive was the family cow camp. The term "camp" should not be confused with camping out, as in the weekend away style. Cow camp meant living for two months in an isolated cabin with no electricity or plumbing, in a rough natural environment surrounded by flies and mosquitoes and mice, with visits from bears and rattlesnakes and meat bees that Dulce Tully Rose said "surely would carry off everything, anything that wasn't nailed down."

So, in such an environment, how did a child pass two months? What were some typical things a child did at cow camp? For one thing, children were expected to work. Their parents depended on them to help out and not just in a token way. Adele remembered doing the domestic chores in the cabin, such as cooking and cleaning. Women's work, she called it, and it wasn't easy in the primitive setting. Dulce's parents looked to her to make sure that the meat bees kept away from the line of jerky they had strung along a clothesline: "My job was to keep the fire going under the jerky. Soon as the sun came up in the morning it was, 'Dulce, get up and start the fires.' Those yellow jackets could carry away a whole line of jerky."

Diane's father expected the children to do such chores as mending fences or moving horses. He worked for the California Youth Authority and had to be away four days each week. He would work the cows before he left and then, Diane recalled, "He gave us a list of things to do until he returned. Put up a fence, do this, do that. When he would show up, if we got our list done, then we could go fishing. But, it's so funny because you learn to listen to your

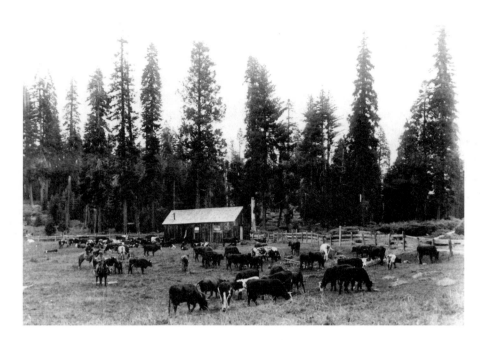

Cowboys spend the summer months in the high country looking after the cattle. The cabin is at the center of life in the cow camp, and sometimes cows graze in the meadow outside the cabin. But the cowboys drive the cows from meadow to meadow within the permit area throughout the summer months. *Courtesy of the Sierra National Forest.*

surroundings. When we'd get quiet and listen we could hear him coming probably forty-five minutes before he would arrive. Sometimes we thought that we could get the work done, so we'd sneak the fishing in and then try to cram when we heard him coming."

But it wasn't all work. The children had precious time to themselves to wander and explore. Dulce and her sister rode horses to the surrounding meadows: "We rode around and enjoyed nature. If we had a good year we picked strawberries. And we went fishing. We never got lost. And anyway we had it drummed into us so that we never thought of getting lost. Give your horse his head and he would bring you home. Right into camp. We [would] just take off and go, and automatically came home, just like a dog. We weren't taught fear."

It would be difficult to imagine such isolation. How did the children learn to handle it? Diane remembered that "we were like little hermit children. We would go up there with the cows, and we would not surface to the public until we had to go back to school. I remember coming out of the mountains and it was like shell shock." Sometimes, in their moving about, they would

bump into campers, not fellow cow campers, but the recreational kind. Diane recalled one of those times:

When I was a little kid and we would go out on our little jobs, we would go places like Rattlesnake Lake, and we would ride down there on our horses. We would be merrily going along our way, and suddenly we would hear a voice. A human—we would be like, "Oh, my gosh." And we would get down there and see smoke from a campfire and it was just like—I mean I'm not kidding—we would just run to get near them. We would go up and say hi, ask them how they're doing. It was like human contact. It was really quite fun.

One wonders how the campers responded to see these three little kids ride up into their camp. It would be fun to see the expressions on their faces though it probably would not have taken long for them to realize why they were there. "It was pretty obvious what we were doing," Diane explained. "We either had some fence stuff, or we'd be moving some cows, or we'd be leading a little packhorse with salt. Our signature of why the heck we were out in the boondocks."

Dulce claimed that she never felt lonely:

People were coming in and out all the time. They would come over to our camp at Graveyard, then over Shuteye and down to North Fork. We would maybe get mail two or three times over the summer months. When we got to going in with the wagons, they would go down a couple times a month...They would let us know if they were going out and ask if we needed anything...You might not see them for days and days, but you knew they were there.

And they had nature. With children and nature there is never a dull moment. It seems that chipmunks made good little pets for the children. They became their friends. Diane recalled, "Oh gosh, you know, I learned to make friends with the animals. And that sounds so crazy, but, when I was little, I remember there was a big log outside the cabin [where] I would set my little chipmunk catcher, and I would catch me a chipmunk and that would be my best friend all summer long. They would ride on my shoulder and everything."

Dulce was more creative with her chipmunks:

The first thing we would do when we got there in the summer time to stay, Jerry [Brown] would catch for each of us kids a little chipmunk.

Oftentimes we would get them ourselves. They would fall out of the nest or out of the tree early in the morning when it was cold, and we would run up and get them. We'd put a string around their necks and pin them to our clothing. And they would stay with us all summer. They can freeze, just like that. So at night we would put them in cans, punch them full of holes—baking powder cans—fill them full of cotton and put them in there.

And the children lived in their imaginations. "There were no video games or T.V.," Diane said, "so you created. You held on to your imagination for longer."

Dulce's sister Dorothy, being four years older than Dulce, grew up fast, and Dulce found herself alone much of the time:

I lived in my imagination. I had certain trees along the road, especially after we left, that I'd say hello to and goodbye to. Along the trail I would give them a little pep talk—like all children. There was one rock, and later the wagon road went right alongside of it. On top of this rock there was a little Tamarack tree—having a heck of a time to live—snow was breaking it down. We'd go by that little tree every spring, and after I would leave in the fall I would give it a little pep talk, and eventually it lived as long as I went to the mountains.

Getting the cows off the mountain in the fall by the September deadline required planning and organization. It could take two weeks to gather the herds together for the big push down the mountain.

You began to see the signs by mid-September. You're hiking in the forest. You see a cowboy on a horse driving ten or twelve cows onto a meadow. Pretty soon, he turns around and works his way back in the direction from where he came while the cows stay put. He probably is going to round up some more and place them where they would stay awhile, where there's grass or water or shade. These holding fields might be fenced, so the cows wouldn't stray. Marking the boundaries with salt logs also helped keep the cows from straying.

"Everybody marked their boundaries with salt logs," Dulce told June English. "You could depend on those cattle not going too far from the salt logs." But some of the experienced cows would not wait for the gathering. "The wise old ones, the leaders, as soon as the Mono winds [intense winds in the Sierra that begin in fall] would start, they would head for lower country. They'd be almost down to North Fork when the rest were just starting out."

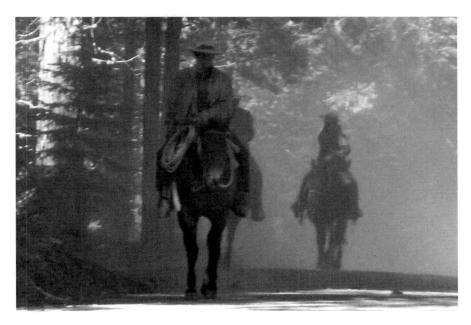

Calvin Sample, a longtime friend of the Toppings, joins the Topping cattle drive every year. Calvin and his wife, Billie, are happy to be part of preserving the cowboy way of life. *Courtesy of Marcia P. Freedman.*

Cattlemen are not permitted to put up permanent fences for gathering and holding their cattle. Part of their time during their summer stays in the forest is spent putting up and dismantling makeshift fences. *Courtesy of the Sierra National Forest.*

Cows that have been trucked to the permit and not driven may not know how to get off the mountain. They tended to go back to where they were let out and dispersed. At the end of the season when it started getting cool, they have the instincts to start heading down the hill to warmer temperatures, but they may not know how to do it. Stragglers needed to be tracked, or they stood the chance of being stranded over the winter and possibly dying. A strategy to find stragglers was to look for tracks and to go to the place they were let out.

Patrick remembered that, in the fall, the calves got big and fat and were kind of wild. The cattlemen always wanted to put off the drive as long as they could, to take advantage of the good feed. But if they waited too long, there was the chance an unseasonable snowstorm would come that would make the gathering cold and miserable. Getting home was not a problem. The cows knew where they were going. A few stragglers would be left behind from time to time, but they usually appeared home a month or so later. "But cattle raising was livelihood," Patrick said, "and you didn't want to lose a cow." They had two or three dogs to help, not mean or vicious, just barking dogs that kept the cattle moving.

Jerry Brown had dogs also. They were trained for working cattle and had no experience with wild animals. Dulce told a story about Jerry taking one of the ranch dogs hunting one time. "After that," she said, "he was through as a cow dog. For driving and handling the cattle he was alright. But to go out in the fall and round up the cattle, if he ran across a bear or a deer track or anything else, he was right after that animal. He couldn't be depended on, so we kept him at the camp." Sometimes a dog can go astray on its own. In his book, *A Shepherd Watches, A Shepherd Sings*, Basque singer-songwriter and former sheepherder Louis Irigaray described a time when he was very young on a drive in the 1930s when one of the sheep dogs began killing sheep during the night. They had to destroy the dog. "Once a *txakurra* [Basque for sheep dog] attacks the band, tasting warm blood, death is the only answer. The dog cannot be turned loose. He'll come back and attack again."

Sometimes the cows roamed, and other methods were used to gather them back. Adele recalled that at her family's permit site the cows would roam everywhere. So, how did they get them back? They knew there were certain meadows the cows preferred. "All summer long you lay out the salt logs, and the cattle would congregate on those meadows," Adele explained. "There were times when we didn't get them all out, particularly when there was an early winter."

One year, before the Bass Lake airport closed in the 1960s, they were able to fly up to look for lost cattle. "They were found on the south fork of the San Joaquin," said Adele, "and so they took mineral blocks and pitched them out of the airplane for them, and maybe even some hay. Some of those cattle survived on their own during the winter. They were in pretty sad condition—their bones kind of rattled in their bodies—but we were able to get them back with the herd the next summer." One of the heifers Adele remembers well. She must have been traumatized by her winter in the mountains because she would not let the horses or mules out of her sight. "We tried to ditch her once when we were going on to another camp or moving cattle somewhere else. We thought we'd go, and she'd just stand in the meadow. But she'd come sniffing up the trail, checking us out. She was not going to be left again."

Dulce Tully Rose lamented that children nowadays miss the kinds of experiences that she had all those years on the cattle drives. She believed that living things, like animals and trees—probably even meat bees—allowed a child's imagination to run wild. It wasn't about whether they made a lot of money. In her interview for *As We Were Told*, Dulce said, "Everyone was the same. No one had any money. We all worked, but we all had fun; we had everything we needed, I guess."

Henry Bohna advised his children not to go into ranching if they wanted to make money. "I guess that is something I would credit my mother and father," said Diane, "for teaching me that materialistic objects and things aren't really what matter. What really matters is being able to track cattle in the high country really, really well, so that you find all those cows and get them gathered, so that when you drive them home from the mountains, they don't stay behind and die. That's what really matters."

A Closer Look at...

Sheep

The farmer and the cowman should be friends.
Oh, the farmer and the cowman should be friends.
One man likes to push a plough, the other likes to chase a cow,
But that's no reason why they can't be friends.
—Rodgers and Hammerstein

The song from the 1955 musical *Oklahoma!* captures, like a snapshot, the spirit of competition that existed at the beginning of the twentieth century among rival settler groups for territory and resources. The Rodgers and Hammerstein play centers on the plains and the clash between cattlemen and farmers over fencing and water rights. In the forests of the Sierra, a battle raged between cattlemen and sheepherders over access to the meadows and streams of the high country with the Sierra Forest Service thrown into the fray.

Until the early 1890s, as Dwight Barnes points out, land and its resources were open to exploitation by special interest groups. President Benjamin Harrison's establishment of the National Forest Reserve in 1891, however, paved the way for the ultimate control of usage on public lands, cattle and sheep grazing being one of the target areas.

Sheepherders never had a chance. Sheep were unpopular with cattlemen, who saw them as competing with cows for the rich feed of the forest meadows. The size of their herds was huge. Louis Irigaray recalled a drive to the high country as a young boy when he was riding a donkey and behind him, the "white faced ewes, thick-bodied animals, creamy white

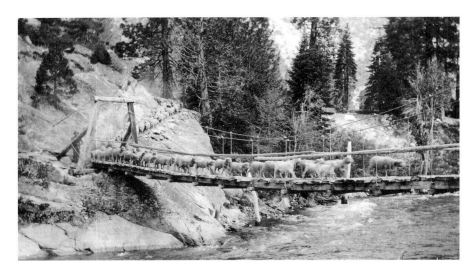

Sheep herds can number into the thousands. To navigate the narrow trails and bridges in the forest, they are sometimes driven single file and slowly make their way. *Courtesy of the Sierra National Forest.*

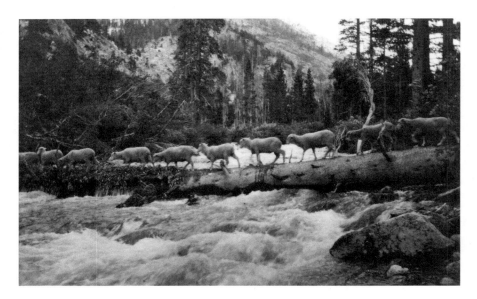

Sheep herders have been accused of downing trees so that their animals can cross over rivers. In this photo of sheep walking over a log, it is not clear whether a tree was downed for the purpose or whether a conveniently available log was placed over the river. *Courtesy of the Sierra National Forest.*

all over with a four-month mat of fleece—fine Merinos—4,000 of them nodding nose to rump, stretched out for more than a mile."

Sheepherding was seen as destructive to the watershed and a threat to the water supply in the forest. Supervisor Charles Shinn in his 1907 article *Work in a National Forest: Sheep in the High Sierra,* wrote regarding sheepherding that "if it is [a threat], the grazing of cattle comes under much the same category. Some of my friends of the [hydroelectric] power plants claim that live stock of every sort should be excluded, because cattle, horses, sheep, etc., all trample up the surface and cause erosion, which fills up the reservoirs."

Not only were the sheep out of favor, but the sheepherders themselves were also criticized for such things as torching their meadows at the end of each season and downing trees to create log bridges to span creeks for the sheep to cross. Sheep are surefooted. A capable lead animal could "take the sheep across a tightrope," Irigaray's herdsman was quoted as saying. But they would not swim the creeks and rivers as the cows did.

The biggest criticism of sheep, however, was directed at their grazing habits. Sheep had the reputation of being voracious eaters, plowing through an area, chomping everything down to the nub and leaving destruction in their wake. Irigaray suggests that with controlled grazing, sheep could help the land by pruning plants down to acceptable size and fertilizing the soil with their droppings. In that way, healthy growth of the plants palatable to the animals would be encouraged the following season, rather than the takeover of plants with deeper tap roots that might be inedible. Shinn also believed it was a management issue. "Men who handle their sheep well, keep off the meadows, have small bands constantly moving, and all that," he wrote, "do not injure the forest, so far as very close and constant observation can decide. Men who handle their sheep poorly, overstock, etc., do injure the forest, as the landowners are finding out." Bart Topping, a local rancher, remarked that even cows can be hard on meadows without proper management: "It's the herder's responsibility. We stay out there all summer, and that's what we do. If a meadow looks like it's being grazed pretty heavily, the cattle need to be moved to another part of the range."

Shinn, ever the fiscal strategist, even saw economic advantage to allowing sheep grazing rights in the forest. He noted that sheep owners were willing to pay private individuals or firms more than twice as much per head as the Forest Service charged. "Let us all take counsel together," he advised, "for things in reason are good things to have. Reasonable wool and mutton are excellent; white sheep away up in the 'blue brush' or eating out a fire-line in summer weeds, may have a place in forest economics after all." Shinn might

have been correct. A Forest Service range report from the 1930s, when sheep were allowed to graze on Goat Mountain just west of Bass Lake, indicated that by grazing the sheep early in the summer, they chewed down early weeds and grasses and in that way cut down the fire hazard better than cattle.

But, despite Shinn's attitude, at the beginning of the twentieth century, as Barnes pointed out, "hundreds of thousands of sheep were grazing on summer pastures in the high mountain meadows, and it appear[ed] that once the Reserve was funded, its primary mission was to drive the sheep out of the hills." Consequently, sheep have been generally absent from the Sierra Forest since that time with one exception. On the eve of World War I, to meet the war emergency, the forest supervisors were ordered to open up the forest to both cattle and sheep and to encourage cattlemen to let go of their prejudices against sheep. This led to large numbers of both cattle and sheep in the forest between 1918 and 1919. It is estimated that in 1918, for example, there were sixty-six thousand sheep and thirty-five thousand head of cattle under permit in the Sierra National Forest.

The patriot status of sheep, however, did not serve to quell the animosity toward them. Shinn was correct when he said that it would be hard "to get men to look at the whole sheep problem in a dispassionate way." The legacy of animosity toward sheep exists to this day.

Don Trower, who was born in North Fork, remembered the negative attitudes of people about sheep. "It was neat when the cattle came by our house," he recalled,

> they ate all the grass on the side of the road. Sometimes the cowboys would stop and rest. They'd come in while their cows grazed outside the fence. We didn't have gates at the driveway, so I'd have to stand out there and make sure the cows didn't get onto the property. For a young boy, it was really a thrill. But with the sheep, it was different. The herders would drive them really slow, and the sheep ate everything on the way. It was like locusts came through. I remember one time when someone brought sheep past our property my dad went out and got so mad, just jumped up and down and ranted and raved. I really felt bad. Those guys couldn't even speak English. They were probably Basque.

Many sheepherders during the period of expulsion from the forest were Basque. Some did not speak English. "People ask, What really is a Basque," Irigaray wrote. "We wish we knew." Labeled a "mystery race" by anthropologists, they were mountaineers and early whalers from the western

Pyrenees and along the Bay of Biscay. "We are French and Spanish and neither, and hold an odd allegiance to a geographical place in the Pyrenees," says Irigaray. There is a bit of a mystery about their ancient language, also. It has been around since before Christ, but its derivation has eluded linguists.

The Basque were not like traditional herders either, American citizens who homesteaded land, built ranches and established communities. Up until the mid-twentieth century, the Basque herders were more itinerant, moving their bands of sheep and toting their trailer homes from place to place, many times leasing land. To this day, California has one of the largest populations of Basque descendants in the country. They live mainly in the San Joaquin Valley in places like Stockton, Fresno and Bakersfield.

THOUGHTS OF A FEMALE RANCHER AND CATTLE DRIVER

DIANE BOHNA CRISP

On being a female in a man's business:
Oh, gosh. You know problems are just a matter of interpretation and how you let them affect your life. I would say that they were more lessons learned and challenges for me to learn to deal with. This is so funny—one of the cutest lessons I ever had was with Lester Bissett because prior to purchasing this permit, I worked for him for a long time, and I gotta tell you that he bought that cattle permit just so that he could hold on to it until I could become financially able to purchase it—to give me the opportunity to purchase it. He was such a sweet, sweet man, a hot-blooded little Frenchman with the biggest heart in the world.

I worked for Lester for a long time. In the beginning, when I was first working for him I took the cows to the mountains. Heck, I'd been doing it for such a long time, I could do it all. I'd line up the crew, getting everybody together. He didn't even go on the cattle drives. He'd show up every once in a while. On the first cattle drive, we got to the end of the time period, and he was writing the checks for the labor for all the people. So then he wrote one to this cowboy and to this cowboy, whatever, and then he got around to me and he wrote me a check and when I looked, it was probably at least twenty dollars per day less than the men that worked off the drive. I don't know if the chicken neck thing came out or what, but I just waited until

everyone left, and I took that check over and I said, "Lester, I have so much respect and admiration for you and I love you so much. If I am worth less money than these people and I am the one that's running the show, I would rather work for you for nothing. Because I will. I will take those cows to the mountains. I will do all this work for nothing. Rather than this. So, you keep this money because I won't work for less than them, but I will work for free."

On mustering the courage to speak her mind:
Well, I knew that Lester was old school and I mean, heck in his day and age I'm sure that was just normal, standard. He never would have hurt me in a million years. He didn't realize there was a challenge. I wanted him to understand that I knew that he wouldn't do anything to hurt me but that what he did was unacceptable and I would rather work for free. The moment I told him that, from there on I made twenty dollars more per day. But that was the epitome. It's like living in a wild kingdom. After that there was never a bobble or a question.

On the cowboys taking orders from her:
When I started to take over, yes, there were circumstances and situations [that were difficult], and they were probably a lesson for me. Because I remember thinking on the first cattle drive that I was in charge—can you imagine the dumbest thing you could do? Well, I did it. I had planned everything. I had all the help lined up. I had everything. We get to our first night of camping, and I had forgotten every kind of utensil. We had none. We did not have a fork. We did not have a spatula. We had nothing. We had to create them out of sticks.

On feeling that the job was too much for her:
Well, when people were asking—'cause they were asking, and asking—What do we do with this? What do we do with that? Everything, and I'm thinkin' Holy Toledo, how in the world did my father know the answer to every one of these specific questions? How did he know this? Then I took a breath and realized that he actually didn't know everything because he would tell me, intelligent people don't know everything, but if they don't know, they know how to find out. And in that situation, you make the best decision that you can possibly make in that particular circumstance on that day at that moment, and you just go with it. And if you learn that there was an easier way or that there was something you could have done a little bit better, well, the next time you come to that decision and that crossroads, then maybe you adjust your decision for that moment. That's how you do it.

On what she considers the most important skills for the job:
Tenacity. You have to have a passion for it. There was a time period when I thought these days were going to be in the past. But I see now that there is a whole evolution that has occurred and there are young people that are getting into this.

A cowman is blessed, or cursed, with an eternal optimistic point of view. The grass will be better this year. The price will be better next year. We can do it if we only do this. I mean they're consistently eternal optimists. And if you're not, you're not going to be in business very long.

About her parents:
My father, I don't know if it's that cattleman disease, the optimistic part, but he would develop this odd ability to make a person feel so special, so needed and such a valued part of something, that he did have success stories—people were so attracted to him. They would come and help us for nothing and ride in the rain under horrible conditions, do it year after year and be so happy to do it.

Dad worked Mount Bullion, the California Youth Authority at the residential facility for boys eighteen to twenty-two-ish. You know, my dad he said that a lot of times what a person is interested in when they are eight or nine years old, it's just pure and honest. And so he would always talk to the boys and find out what they liked when they were that age. What his idea was, a lot of those kids had been in gangs, and they had made bad choices. After all, they were in the California Youth Authority residence. They had to know they kind of screwed up, unless they were just idiots. But he tried to give them a whole new perspective on what really mattered in life and to bring them back to that time frame when it was innocent and the gangs hadn't corrupted their choices.

Mother was an artist. She did oil paintings. Her real thing was painting horses. Her family had a cattle ranch at Grub Gulch. I still drive my cows through her old home place, which her family homesteaded back in the late 1800s. She graduated eighth grade from Grub Gulch grammar school. My father and mother met at a square dance. My mother was very well read. Up in the mountains at camp she read all the time. You could talk to her about all kinds of things. She was self-taught.

Mother also loved music. She always had a radio on in the house. I knew she played the guitar when she was young. I've seen pictures of her and her sister, who was also a musician. It wasn't until about five years ago, when

she was diagnosed with Alzheimer's and she was getting to the point where things were getting bad, where she knew something was wrong, but she didn't know what it was, she brought out the guitar. I had never seen it. She said to me, "Diana, I want you to take this home. Only if you promise you'll take care of it." It was one of her most precious things.

On her photography:

Whenever I photograph anything, I want people to not only see what I saw but to feel what I felt when I took that picture. I like people to be able to position themselves in the situation, even if it's only for a glimpse. When they walk by my image on a wall, hopefully they'll just take a breath, and then go back to what they were doing.

When you look at this picture, for example, [pointing to a photo on the wall] you know that it's a solitary cowboy. He's with his dog. He's looking down. You see where he is. You know that's why he does what he does.

I love taking pictures, and I really enjoy doing photography. But my number one love in life is cattle ranching and that will be forever.

Part Two

HARD-WORKING WATER

Hydroelectricity

A Beginning, A Middle and The Beginning

It was 1885. John Eastwood, a civil engineer, had a plan. He was going to build a hydroelectric power plant and bring electricity to Fresno. Perhaps he was inspired by the appearance in 1882 of the world's first commercial central hydroelectric power plant in Appleton, Wisconsin, or the first such project in the Pacific Northwest in Spokane, Washington, in 1885. Whatever spurred him on, it appears that he set out to plan his own project, apparently targeting the north fork of Willow Creek, then known as North Fork of the San Joaquin River, as the source of water power.

One can imagine him traipsing through the foothills with his small burro, possibly following the steep, narrow, rocky channel along Willow Creek, observing and taking notes. Perhaps his travels brought him to the place where the north and south forks of Willow Creek came together, a short distance south of the tiny settlement of North Fork. He might have entered North Fork, where the two forks of the creek pass within half a mile of each other. There, he likely would have bedded down for a night at Brown's Place. His animal would have been cared for, and he would have had a hot meal and a good night's sleep. Crane Valley would have most assuredly been Eastwood's next stop. He would have known about the falls, and like members of the Mariposa Battalion in 1850 and the early settlers in Crane Valley, he would have understood the potential of the creek as a source of power. So, he would have continued to follow the north fork of the creek, calculating distances and gauging stream flow.

But Eastwood's priority was to bring electricity to Fresno, and he knew that getting electrical power to Fresno from as far away as Crane Valley—more than fifty miles—would not be the optimal choice. So he had to come up with

a better plan. He had to map out the shortest route from a substantial water source to the steepest hill to send the water down, one that would be as close to Fresno as possible.

Eastwood chose the confluence of the north and south forks of Willow Creek as the place from which to divert the water. His plan involved building a ditch that followed a ridge five miles to the top of a bluff that stood 1,400 feet above a likely location for the plant. By building a dam on the bluff, he could create a forebay to control the water entering the penstocks that would lead to the powerhouse below.

Eastwood's plans were at the cutting edge of hydroelectric development in California at that time. For example, within two years of his explorations, a company in southern California built the first hydroelectric plant in the state in Highgrove (present-day Riverside). In the following four years, two other plants appeared, also in southern California, one claiming a world record transmission of twenty-nine miles between Pomona and San Bernardino.

Fast forward to 1896: Eastwood and his business partner, the industrialist John S. Seymour, had formed the San Joaquin Electric Company, obtained a lighting contract with the city of Fresno and built San Joaquin Powerhouse Number One, 1,400 feet below the forebay—which we know today as Corrine Lake—and with record-breaking transmission lines of thirty-seven miles.

The construction of San Joaquin Powerhouse Number One stirred public interest, some not positive. Critics of the design maintained that the head was too great and would create unmanageable pressures in the system, built to transmit eleven thousand volts of power. Bob Whitley, a former PG&E systems operator, explained that nowadays eleven thousand volts would be considered distribution, but for the technology of that time, eleven thousand volts of transmission was a lot to manage to keep it from going to ground and issues like that. The other target of criticism was the thirty-seven-mile length of the line connecting the powerhouse to Fresno.

Opposite, top: The South Fork Willow Creek diversion flume was part of the original system designed by John Eastwood in 1897. The water that is diverted from South Fork Willow Creek will combine with water diverted from North Fork Willow Creek and will travel in a five-mile ditch that spills into Corrine Lake. From there the water will be directed into the penstocks that lead to the powerhouse on Kerckhoff Lake, 1,400 feet below. *Courtesy of Marcia P. Freedman*

Opposite, bottom: The swinging bridge in the photo spans North Fork Willow Creek in the area of its confluence with South Fork Willow Creek. Above the bridge to the left is the South Fork diversion flume. *Courtesy of Marcia P. Freedman.*

Steven Hubbard, in his *Images of America: Powerhouses of the Sierra Nevada*, described the building of the early powerhouses as an adaptive technology. As the demand for electricity rose during the latter part of the nineteenth century, builders of hydroelectric systems had to call on local craftsmen to construct, and sometimes invent, much of the equipment. "Local woodworking craftsmen designed flumes," wrote Hubbard. "Pipe fitters built shafts, pulleys and speed regulators. Harness makers crafted leather belts for power transmission between machines." The powerhouse operators, whose experience came from slow-speed mills and factories, had to develop the knowledge and skill to run the high-speed drive systems required for electrical generators. John Eastwood, when he looked back at the early days, was quoted as saying that "in those days everything was experimental and everybody connected with the business was a novice."

George P. Low was present when the motors of San Joaquin Powerhouse Number One were turned on. In his 1896 *Journal of Electricity* article "The Fresno Transmission Plant," he described the scene at the flipping of the switch:

> *The visitor to the powerhouse of the San Joaquin Electric Company* [on observing the] *heavy cannonading that accompanies the starting of a plant* [would be] *aware that the installation is operated under a higher head of water than any other electric transmission plant in the world, but he is not prepared for an outburst resembling that of artillery...In truth he has received his first lesson of the terrific energy represented in a column of water which throws the gauge to about 600 pounds, and the rattle as of the "machine guns" is readily explained by the fact that while idle the chamber of the nozzle is filled with air, and upon opening the gate, the water rushes in, filling the lower portion of the nozzle first, then compressing the air in the upper part, and in the churning of the air that follows, bubble after bubble of air compressed to over 600 pounds per square inch is released, forming a discharge of pneumatic musketry that, reverberating through the canyons, bears tidings to the ranchers even six miles distant of the starting of the water wheels.*

Unfortunately, Willow Creek's entrée into hydroelectricity did not go as smoothly as Eastwood and Seymour would have liked. Human and mechanical problems dogged the operation from the beginning. The opinions of Eastwood's critics appeared prophetic as mechanical problems occurred in the high-pressure pipes and devices that were installed to control the tremendous force of the water. Design flaws, such as lead seals on pipe joints

expanding and contracting with the changing night and day temperatures, caused leaks that forced the system to shut down with regularity. The mistake of an inexperienced engineer who they had hired resulted in the flooding of the powerhouse and a serious rupture in the pipeline five hundred feet above it that stopped production for four months.

But the major impediment to San Joaquin Electric Company came from its rival, the Fresno Gas and Electric Company. In those early days, before the advent of discrete utility districts, utility companies were free to compete with each other over territory. In an industrial cowboy–like move, Fulton Berry, head of Fresno Gas and Electric, purchased hundreds of acres in the area of Crane Valley, sent men into the mountains to file claims to riparian rights, dug a mile-long ditch and diverted a large portion of the flow away from Willow Creek to an area of manzanita and brush. This, added to serious drought years between 1896 and 1899, caused San Joaquin Electric Company to shut down frequently. In 1899, the company declared bankruptcy.

At that point Eastwood and Seymour went their separate ways. A wiser and still determined Eastwood returned to the mountains, searching for the ample water sources needed to sustain a hydroelectric system. "For weeks," wrote Gene Rose in his 1987 book *Reflections of Shaver Lake*, "he roamed the wilderness of the upper San Joaquin River, alone and unaided, calculating stream flows and suitable dam sites, guided by a burning desire to succeed." And succeed he did, designing one of the largest facilities of its time: the Big Creek hydroelectric system of the San Joaquin watershed.

As for Seymour, he applied his astute business sense to his job as trustee of the San Joaquin Electric Company receivership. Between 1899 and 1901, by an apparent force of will and financial manipulation, most likely involving some personal finances as well as outside investments, he was able to continue the operation of the disabled San Joaquin Powerhouse Number One. In addition, perhaps because he had not lost confidence in Eastwood's vision of hydroelectric development along Willow Creek, Seymour financed the construction of a small earthen dam at Crane Valley. By doing this he created the first Crane Valley reservoir—Bass Lake part one.

In her 1977 article *The Way It Was*, Doris Scovel writes about Jess Bigelow, who was a small boy when he drove with his step-grandfather to Crane Valley in a horse and cart. His step-grandfather wanted to sell hay to the San Joaquin Electric Company. Bigelow remembered seeing goats tramping over the small earthen dam the company was building in order to pack the moistened dirt down. According to an interview with John and Harriet O'Neal in *As We Were*

Told, the goats belonged to them. John O'Neal had entered into a contract with the electric company for the use of his goats. The O'Neals, newly married at the time, lived in a tent at the dam location for several months. The goats, after their day's work, were let free to graze on the mountain west of Crane Valley, which was subsequently named Goat Mountain.

In 1902, Seymour purchased back much of the Fresno Gas and Electric Company's land and the water rights adjacent to Crane Valley, thus eliminating that competitor from the scene. This enhanced the San Joaquin Electric Company's attractiveness when it went on the auction block. That year it was purchased by William G. Kerckhoff, a Los Angeles entrepreneur in hydroelectricity, and the engineer A.G. Balch. After purchasing the company, Kerckhoff and Balch changed the name of the company to the San Joaquin Power Company. Then they hired Albert G. Wishon to manage the new enterprise.

While Seymour had managed to attract backers for the resurrected power company, it was Wishon who took on the job of convincing hesitant financiers, dubious engineers and the skeptical public that hydropower could be a financial and technological boon to the valley. Based on the disastrous outcome of the San Joaquin Electric Company's experiment, it seems his job would have been insurmountable. But Wishon was obviously a determined and creative administrator. Over a ten-year period, from the time he was named manager of the San Joaquin Power Company to the construction of San Joaquin Powerhouse Number Three and the completion of an updated, enlarged Crane Valley Dam (Bass Lake part two), Wishon conducted a vigorous campaign of public education and system development. He must have been pretty good at what he did. By 1913, San Joaquin Power Company had reorganized into the San Joaquin Light and Power Corporation; had achieved a two thousand fold increase in generating power; was running hundreds of miles of transmission and distribution lines over ten valley counties; expanded its territory to five million acres of irrigable land; ran streetcars, first in Bakersfield in 1910 and then in Fresno in 1913; and employed one thousand people. And that was only the beginning.

The rest is history, as they say. With the growth of population in the San Joaquin Valley, the expansion of agriculture, the increase in farmers' reliance on refrigeration, the growth of the oil industry and, in 1923, San Joaquin Light and Power's bringing electricity to the Madera Sugar Pine Lumber Company through power lines from Crane Valley, the company grew exponentially.

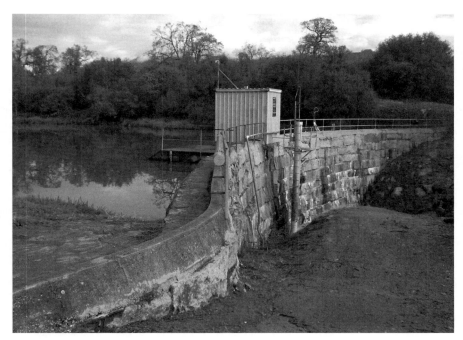

Above: The dam at San Joaquin Forebay Number Two was constructed in 1906 when the San Joaquin Power House Number Two was built. The rock for the dam was harvested from a small quarry nearby. *Courtesy of Marcia P. Freedman.*

Left: The Crane Valley Power House, constructed in 1919. *Courtesy of the Henry Madden Library at California State University Fresno.*

In 1925, Albert Wishon's son, Emory, joined the company as vice-president and, in 1930, became president of the board of directors. The opportunity arose in that year for a merger with San Joaquin Light and Power's rival company, PG&E, which had been stringing power lines across the mountains to mines in Coarsegold and Grub Gulch and later to the sanatorium in Ahwahnee. Both Albert and Emory Wishon welcomed it, in Albert Wishon words, "as a logical move to bring about uniform operation and development of electric and gas resources of northern and central California." After the PG&E takeover, Emory continued serving as the president of the board of directors after the death of his father in 1936.

A Closer Look at...
Weather, Water and Looking Back

Weather

How can one be uninfluenced by geography? One cannot. We all are affected at the least by the weather, which is specific to geography.

—David Mamet

Skies of a blue that can take your breath away. Winds fierce enough to bring down a grove of ponderosas. Snow-laden pines bending as if in prayer. Thunderstorms. Pounding hail.

The weather conditions in the Central Sierra Forest are exceptional and unpredictable. Too much precipitation, not enough precipitation, a late spring snowstorm, early rains—these are part of the reality of living and working in the mountains. They are also the reality that can imperil the workings of a hydroelectric system and sometimes can pose serious threats to the systems operators themselves.

Ron Severe's father put himself in harm's way when he worked as a ditch tender for San Joaquin Light and Power Corporation and then PG&E during the 1920s and 1930s. Severe related a story about what happened to his father one night when he was out ditch tending along the San Joaquin's Powerhouse Number Three forebay below the Crane Valley Dam. Ditch tenders, in the early days, were systems operators whose sole assignment was to take care of the ditches and flumes within their designated areas.

The grizzly intake at Forebay Number Two. *Courtesy of Marcia P. Freedman.*

They built cabins and "lived close to their section of responsibility," Steven Hubbard wrote in his book, *Images of America: Powerhouses of the Sierra Nevada.* The tenders were personally responsible for ensuring that the ditch would not blow out or suffer any other extreme failure that might cause a local flood. They patrolled constantly—in the early days, on horseback—looking for leaks, breaks and debris or dealing with water thieves who were known to tap into the water system. Acknowledging the dangers that faced the ditch tender, Hubbard wrote that "in times of winter storms, when ice would form over the grizzly [a gate-like structure at the head of the penstock that keeps debris from being sucked up into the turbines and generators], sometimes there was no alternative for removing ice except to tie on a safety rope, grab an axe, and climb down into the canal."

The incident with Ron Severe's father occurred one night during a storm when he went to check on the ditch. He had brought with him the large, heavy rake with a ten-foot handle that ditch tenders used in earlier days for scraping pine needles and other debris off the face of the grizzly. That night, Severe said, the boards were not in place over the ditch. But his father didn't notice.

"He stepped over the open void," said Severe, "raked the grizzly, got in his car and went about his business for the evening. When he went there the next day and saw that he had stepped right over it, he realized he could've been sucked tightly against the grizzly. Gives one the shakes just thinking about it."

Rain and melting snow can bring their own set of problems for operators. Whitley recalled a situation in 1981 when he was working as a roving operator. In February, at PG&E's Balch hydroelectric camp on the north fork of the King's River, there was an enormous snowstorm that dropped four feet of snow at the four thousand foot level. That's a lot of snow for that elevation. An unseasonably warm rain followed, and twenty-one inches of rain fell in seven days. All the snow up to six thousand feet melted. "We had wall to wall water," said Whitley. "We battled it for a week, watching as the lake level rose and making sure the level didn't exceed the flood level."

A storm blows in. Water levels rise in the lakes. From inside a powerhouse, the operator watches as water begins to seep in. Retired PG&E powerhouse foreman Tom Hebrard described such a situation he attended to at the Wishon Powerhouse. Wishon is a unique situation, as powerhouses go. It's the point of the last input of Willow Creek water. The water exits the Wishon powerhouse into the Kerckhoff Lake Reservoir, which also receives San Joaquin River water through its powerhouse. So waters from PG&E's Crane Valley Project and Southern California Edison San Joaquin systems enter the reservoir. On that night in 1956, Hebrard watched the water coming in as he received reports from Southern California Edison on its runoff combining with PG&E water. He knew that when a generator closes down, PG&E can still route the power through its system. There are certain places where there are ties between the PG&E and Edison systems so that electricity can run either way. Hebrard told SCE that Wishon was shutting down.

What does that mean? Separate the generators. Close the gates that keep the water output to the lake from backing up into the powerhouse. Shut the big metal door that stops the outside lake water from entering the powerhouse. Engage the floodwall around the powerhouse that seals the main door. Pump out any leakage. That was in the days before automation, when powerhouses had to be manned twenty-four hours. Nowadays, if a storm comes in and the wind is blowing, hitting the line, starting to knock the system down, there are relays to automatically separate out the generators.

In 1956, recalled Hebrard, there was no wall around the powerhouse at Wishon. They had a heavy winter that year. The water came up. The lake rose. The water poured through the windows into the powerhouse. Water and

mud inundated the generators. They had to muck out the whole powerhouse, tear the generators apart, clean them and put them all back together.

Then there was the New Year's Day flood of 1996–97. Whitley tells his personal story:

> *The end of December brought historic rains to Central California, of a hundred year flood volume. The San Joaquin River crested at over one hundred thousand cubic feet of water per second. The Crane Valley system was off line and secured against flooding. After the 1956 floods, Wishon Powerhouse had a flood control wall built around it approximately thirty feet high. The main access door in the wall was secured against the rising waters, and the plant was manned around the clock to keep the sump pumps running and the leakage water from the river at bay. A personnel access way through the upper section of the floodwall provides an escape hatch as a last resort.*
>
> *I had been working for thirty continuous hours and decided to go home for a meal and a rest. It was four in the afternoon. Around eight o'clock, dispatch called and requested I go help John [the systems operator on duty] at Wishon Powerhouse. As I approached Kerckhoff lake and Smalley Cove campground, it was evident John wouldn't get my help. The water level was already ten feet over the road leading to the powerhouse along the lakeshore. Poor John was left alone to watch the water rise until it reached the personnel access way. The river crested just a couple of feet over the bottom of the access way long enough to flood the powerhouse to almost the second floor. Luckily, John did not have to make an emergency escape. But months of cleanup and drying out followed before service was restored.*

WATER

A dialectical interaction of humans and the natural environment, rather than a one-sided conquest of nature, framed the processes by which western society and industry established its foothold.

—David Igler

There is a ditch high in the Sierra National Forest located three miles east of North Fork Willow Creek. The ditch was designed to capture spring runoff, receive water diverted from West Fork Chiquito Creek and deliver the water to a small adjacent storage reservoir, Chilkoot Lake. When the earthen

dam on the lake is open, water flows into Chilkoot Creek. Three miles downstream, Chilkoot Creek runs into North Fork Willow Creek, and the combined waters travel several miles south to Bass Lake, the largest storage reservoir in the PG&E Crane Valley hydroelectric system.

If this seems like a convoluted method for supplying Bass Lake with Willow Creek water, well, it is. But it's a way to beef up the supply of water when the water level in creeks is down, say in the late summer months and before the fall rains and winter snows have begun. Willow Creek, at its fullest, doesn't have enough water to fill Bass Lake. As Eastwood and Seymour learned the hard way, without enough water, the system shuts down. So other waters have to be tapped. The ditch along Chilkoot Lake is one of the auxiliary water sources in the system.

"You'd go up early in the season and drain the lake," said Whitley. "Then hopefully it would fill a second time, so it could be drained again." Climate and other conditions, such as the state of the dam or the ditch, or the lake itself, determine whether this can happen.

PG&E used to send crews up every fall with backhoes to clean the ditch or deepen the channel, Whitley explained. This kept the ecology of the area pretty healthy and allowed for the maximum capture of water. But the Chilkoot mini-system is located in the Sierra National Forest, as are another seven hundred acres of PG&E's Willow Creek hydroelectric project. Since the passage of the National Wilderness System under the Wilderness Act during the 1960s, wilderness management is required to address such ecology-based issues as low-impact, leave-no-trace usage, preservation of historical and archaeological sites, protection of natural resources, administering permits for special projects, controlling logging and grazing and monitoring hydroelectric systems, to name a few. PG&E and the Forest Service have a licensing agreement that requires PG&E to follow protocol based on the Wilderness Preservation Act. So the process for PG&E to obtain permits for such things as bringing backhoes into the forest can be slow and the repair economically impractical. If the ditch wall blows out at Chilkoot or rocks or debris begin to fill it in, if the stability of the dam becomes compromised or grasses threaten to overtake the lake, the best that can be done is a patch job or minor clearance until more permanent repairs are possible.

In a way, the issues related to running Chilkoot are not unlike what it takes to run the entire operation: find the closest water, direct it, keep it flowing. However, the challenge of keeping the water flowing takes on a more serious aspect once the water enters Bass Lake, which is the main starting point for hydroelectric production.

The Bass Lake reservoir is created by the Crane Valley Dam, which impounds North Fork Willow Creek. The lake covers a drainage area of fifty square miles that spans elevations from 900 to 7,500 feet. In addition to the Chilkoot water, Bass Lake is supplemented by water from several small creeks, as well as from South Fork Willow Creek through the Brown's Creek diversion. Downstream from Bass Lake the system encompasses two other lakes—Manzanita and Corrine—five powerhouses, a fifteen-mile network of underground, underwater, above ground and in-ground ditches, tunnels, flumes and penstocks, plus miles and miles of transmission lines.

Corrine Lake is the third sister in the chain of connected lakes. It sits at 2,500-foot elevation atop a flat outcropping. It is small, just nine acres. The grasses are filling it in, as if trying to reclaim their natural place. Corrine has no other purpose than to collect water that will be sent down to the Wishon Powerhouse on Kerckhoff Lake 1,400 feet below. As you walk along the ditch leading to the lake, you can see places where there were blowouts, where the cement wall broke and the ditch was rerouted, sometimes through the hillsides, to shorten the distance, to allow the water to travel faster. The signs of constant maintenance and the ongoing effort to hold back the land that wants to return to its natural state are clear: patched leaks, pipes and valves used for dredging silt that collects in the slower, wider parts of the ditch.

The day-to-day job of the operators and crews who oversee the maintenance and repair of the system involves keeping the water levels sufficiently high and maintaining the flow at optimal head for running the turbines and generators in the powerhouses. Considering the complexity of the system, and taking into account that the structures were developed between 1890 and 1920 with many of the original parts still in operation, it's easy to imagine the enormity of the job.

A water systems operator is expected to do a job that involves everything from operating powerhouses and conducting line switching to cleaning trash racks and removing fallen trees and other debris, as well as performing preventative and routine maintenance on a variety of vehicles and equipment, operating construction equipment and much more.

Whitley admitted that the operator generally wears many hats and that the range of skills and knowledge required is quite broad. "You get in there, and you break in," Whitley said. "You learn the plants. You learn the geography of the area. You learn where the head works, on Brown's ditch, for example. You learn little pieces. So you know where this stuff is in an emergency." After that, it's about maintaining skills, keeping up with advances in technology and gaining experience.

If hydroelectric developers saw themselves as "simplifying nature and bringing it under control," in David Igler's words, those who have experience keeping the system running probably would chuckle. They understand that nature, like the self-reliant teenager, is constantly poised to go its own way. A hawk takes off, and its wingspan crosses two wires and causes an outage. A beaver chooses the confluence of the north and south forks of Willow Creek to construct its dam, and the water flow to the flume is stopped. A tree growing out of an earthen dam dies, and its rotted roots become a conduit for water, threatening the stability of the system. These are the kinds of natural phenomena that confront systems operators as they go out into the field to troubleshoot problems.

Or, the difficulty could be in the creek itself. According to Whitley, the water in the mountain creeks is clear all year round. Anyone who has hiked along the creeks in the Sierra Forest knows this to be true. In times of high runoff, the water may become cloudy, Whitley explained. But this is not of major concern. An opaque section of water, however, can be a red flag. It might indicate that silt has been washed down from soil deposits where erosion or some other destabilized situation exists. According to Andy Stone, hydrologist for the Forest Service, destabilization can occur for many reasons. Much damage was done, for example, during the railroad-logging era at the turn of the century. The numerous railroad grade roads crossed landscape and stream drainages and created instability in the stream channels upstream.

Silting brings potential problems for the environment: filling holes where fish might live, reducing the amount of drinking water for wildlife and domestic animals, damaging habitat or simply having a bad effect on the water quality. In such cases, the systems operator goes in, assesses the situation and patches things up by stabilizing soils or replacing culverts until the crew can come and do the repairs. "It's called mitigation," Whitley explained. "Mitigation is more like an emergency action, like being an EMT." It requires quick decision-making, right there, out in the field, in the midst of the crisis.

Aside from nature's intrusion, technical problems arise all the time that present operators with their own unique challenges. A sidewall blows out, and water runs down the hillside instead of in the ditch. This is an emergency situation. At such times, the operator may open up places along the ditch where different waters can be accessed or pull out boards, as they did on Brown's ditch, to help redirect the flow of water into the spill channel and avoid erosion. Knowledge and intuition, the science and art of the operator's job, work hand in hand in these emergency situations.

And what about outages? Electrical outages happen regularly in mountain and foothill communities, especially in wintertime. Imagine walking into your house carrying the ice cream cake you just purchased for your daughter's birthday party. The telltale signs are clear. The air is oddly quiet. The clock on the stove is off, and the lights don't work. It can't be! Not now! Not again! The frustration of the general public with outages is understandable. Sometimes they last for hours, enough time to melt that ice cream cake.

But an outage can have more serious repercussions when lack of water, heat and refrigeration go on for a long time. After the severe storms of March 2011, the outages lasted more than a week in some communities. Public response to PG&E's handling of those outages ranged from disparagement to adulation. Some elderly and ill people suffered terribly during that time and accused PG&E of lack of concern. On the other hand, PG&E received accolades from local citizens for their response. The local chapter of the Good Bears of the World recognized PG&E with their Angels Amongst Us award.

As Whitley explained, restoration of power outages depends on setting priorities. If the safety of a dam is threatened, or if the water level monitoring system has been compromised, these are high priority issues for flood control. In these cases, fixing the water system may take priority over restoring power to private homes and getting a community up and running. These are some of the decisions that have to be made during outages, and the operators are there to assess and advise.

LOOKING BACK

You know, there is so much we could have learned, but we never asked. It's like that, you know. Sometimes I'll think to myself, I need to find out about that, and then I think, there's no one left who could tell me.

—Ron Severe

PG&E offers a man a job as a snow surveyor at Chilkoot Lake, a job he had never done before in a place he had never been before, and he says, yeah, sure, when asked if he wants it. He is hooked up with his partner who's equally inexperienced. They strap on their snowshoes and trudge off together from the Pines Village at Bass Lake into the forest toward their destination, six miles to the northeast.

That was in the mid-1930s, and the man was Ron Severe's father, who had been hired back by PG&E after a two-year layoff during the Depression. The story goes that the two surveyors missed the turnoff that would have led them east toward their destination, Chilkoot Lake. Instead they must have continued heading north, because they ended up at Jones' store, several miles ahead. As luck would have it, they were able to jimmy a second-story window that peeked out from the snow-covered building. Once inside they found a map tacked to the wall that showed them where they were and where they wanted to be. After that, it was easy to get to Chilkoot Lake. Their next task was to find the snow course and the poles at the place where the snow surveys were done.

They must have made out all right because their job lasted and expanded to include measuring streams in summertime. The summer job title was hydrographer. They would ride out on horseback, travel from cabin to cabin, restocking them with supplies that they would use in the wintertime when they were snow surveying. In the course of cabin hopping, they donned their hydrographer hats and measured streams. It would take them upwards of a month to complete their work.

It's not clear how long Severe's father continued in his snow surveyor-hydrographer job. At some point the family moved to PG&E housing at Bass Lake—located at present-day Miller's Landing—and his father began taking on operator responsibilities.

When he was little, his father would bring him along on his various jobs. One time they were at Chilkoot Lake, and Severe watched his father pull out the dam gates and release the water into Chilkoot Creek. Severe remembers the lake as being small and shallow, almost like a big meadow. His father said that there wasn't a lot of water in Chilkoot, that, at best, it could bring the Bass Lake Reservoir up four or five inches. Nothing significant. But every bit counts.

The most fun was when his father brought him to the powerhouse. Severe was fascinated by all the valves and switches, the sequence of things needed to bring the RPM to a specified level before the system could be up and running. The noise must have been enormous. "It's all automated now," remarked Severe. "They could probably sit in San Francisco and turn it on from there."

There were drawbacks to living at the Bass Lake compound, not for Severe, who enjoyed living there, but for his mother. In the wintertime, it was isolated and cold. Because of its particular exposure, the snow would stay all winter in the PG&E cove. In the summertime, Severe's mother had problems

with the tourists peeking into their window, disrespecting their privacy. One time she had a run-in with a group of women. "She had a big bed of xenia in the front yard," explained Severe. "Beautiful. Big. I still remember them. One day she looked out the window, and there were two or three ladies cutting her xenias. She went out there and confronted them. 'What are you guys doing?' 'Well,' came the answer, 'we're getting a bouquet for the table in our cabin.' And she said, 'That's my flowerbed.' And the women looked at her and said, 'We didn't realize anyone lived here.' So tourists were not high on her list," said Severe. The family lived at Bass Lake for eleven years, between 1935 and 1946.

SOME HYDROELECTRICITY TERMS

AFTERBAY

The body of water immediately downstream from a power plant that regulates fluctuating discharges from a hydroelectric power plant. Discharged water could be stored until it is needed at the next powerhouse in the system.

DAM

A barrier built to hold back flowing water.

DITCH

A long, narrow channel dug into the earth, for drainage.

FLUME

An artificial channel, usually an inclined chute or trough, for carrying water to furnish power, transport logs down a mountainside.

FOREBAY

The body of water immediately upstream from a power plant.

HEAD

The difference in height between the water crest (or source) and the water outflow, i.e. power plant. The power of the flow of water to the powerhouse.

HYDROPOWER

Electricity produced at dams by water falling through turbines.

PENSTOCK

Conduit that carries a rapid flow of water controlled by a sluice gate. A component of a hydropower plant; a pipe that delivers water to the turbine.

POWERHOUSE

A complex of installations and equipment that is used to convert the energy of a stream of water into electrical energy.

SPILLWAY

Structures constructed to provide safe release of flood waters from a dam to a downstream are normally the river on which the dam has been constructed.

TUNNEL

An artificial underground passage, especially one built through a hill or under a building, road or river—or lake.

CRANE VALLEY'S HYDROELECTRIC SYSTEM TIMELINE

1890 Chilkoot Dam constructed (creates Chilkoot Reservoir, originally for watering cattle).

1896 San Joaquin Powerhouse no. 1 constructed.

1896 Corrine Dam constructed (creates Corrine Lake, SJ no. 1 Forebay).

1902 First Crane Valley Dam.

1906 San Joaquin Powerhouse no. 3 constructed.

1910 Second Crane Valley Dam (replaces first Crane Valley Dam; creates Bass Lake Reservoir).

1911 A.G. Wishon Powerhouse constructed (replaces SJ no. 1.; the last intake point for Willow Creek water; water released to the San Joaquin River).

1912 Manzanita Lake afterbay created.

1917 San Joaquin Powerhouse no. 2 constructed. As was the fashion of the time, the building was constructed in California Mission Revival style, with a tiled roof, smooth stucco exterior, arched windows and overhanging eaves and exposed rafters.

1919 Crane Valley Powerhouse constructed.

1919 San Joaquin no. 1-A Powerhouse constructed (located just above Corrine Lake forebay). Also constructed in California Mission Revival style.

1920 Kerckhoff Powerhouse and Reservoir constructed (first system to use San Joaquin water; A.G. Wishon Powerhouse releases Willow Creek water into the reservoir).

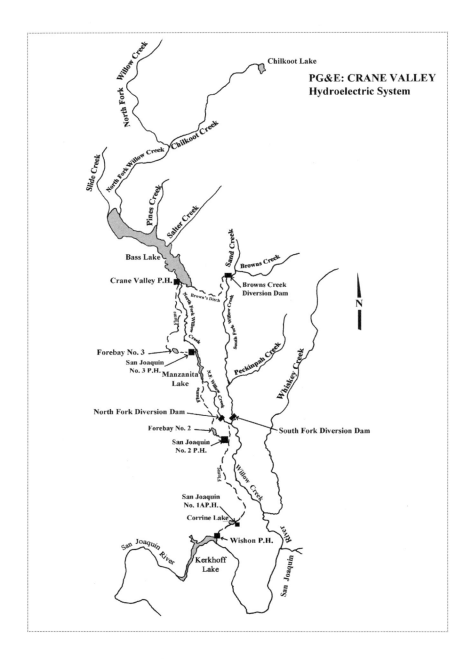

Map of PG&E Hydroelectric System compiled and copied by Marcia P. Freedman from a
NEPA Environmental Review of PG&E.

Part Three

HOW DO WE WANT TO WALK ON THE LAND?

The Same Willow Creek That Goes into Bass Lake

Roughly three-quarters of the Willow Creek watershed lies within the Sierra National Forest. That's sixty thousand acres of public land open to anyone to do anything they want that doesn't break the law, do damage or infringe on the rights of others. It so happens, however, that the most well-known spot for recreation in the watershed is the privately owned eleven-hundred-acre Bass Lake, PG&E's major reservoir in its Crane Valley hydroelectric system.

The development of Bass Lake for recreation traces back to 1901 when a small earthen dam was built across Willow Creek, inundating a portion of Crane Valley. It didn't take too long after that for private investors to recognize the recreational potential of the small reservoir situated, as it was, in a beautiful valley bordered by vast conifer forests.

One might be tempted to speculate what would have happened in Crane Valley if John Seymore had not pursued hydroelectric development after his company declared bankruptcy or if instead he had joined his partner, John Eastwood, on his hydroelectric engineering adventure at Big Creek. Would the people who had created the viable, economically sound settlement in Crane Valley have continued developing the community? Would the great-great-grandchildren of those families be sending their children to the school built by John Beasore and George Sharpton? Or would Crane Valley have been annexed in 1905 into the newly established Sierra National Forest?

There's no way to tell, of course. As it was, by the time the dam was completed, the Crane Valley homesteaders—families like the Sharptons, the Beasores and the Teafords—had already abandoned their lumber mills, their

ranches and farms, closed the polling precinct at John Beasore's ranch and packed up and relocated to surrounding areas such as North Fork, Fresno Flats (Oakhurst) and Coarsegold.

It was George Teaford's land, located on the northeast side of the valley, that caught the attention of recreation developer William Haskell. In 1904, he and his partner, William Day, an actor interested in creating a retreat for artists, obtained a lease from the San Joaquin Power and Light Company, forerunner of PG&E. They built a sawmill near Willow Creek, constructed cabins, and opened the Pines Resort, the first private resort at Crane Valley.

The original cabin built by George Teaford in the early 1880s was located at the Pines Resort. It remained as a historical landmark at Bass Lake until the early 1960s when it was dismantled to make room for a riding stable that was being built nearby. In a 1963 *Fresno Bee* article, Otis Teaford, George's son who was born in the cabin, when asked how he felt about the destruction of his birthplace, was quoted as saying that "all development is good for a country." Today, the Pines has evolved into a resort village with shops, services, private homes, rental units, luxury accommodations and a conference center.

Another resort at Bass Lake that appears to have had its beginnings during the earliest years of dam construction is the present-day Miller's Landing, a section of Sierra National Forest along a cove on the northwest side of the lake, with cabins and boat docks, a general store and a grill. Considered the second-oldest resort born out of hydroelectric development at Crane Valley, Miller's Landing was thought to have started as a supply store for the construction workers' camp during the period of dam enlargement, 1907– 10. Miller's Landing operates under a permit from the Forest Service.

If hydroelectric development spawned interest in recreation in Crane Valley, it was the casual use of the adjacent Sierra Forest by hikers, hunters, campers, fishermen and others that raised interest in recreation as a valid use of the forest. Ultimately, the National Forest Service would come to consider recreation, along with resource management, as a legitimate, economically feasible use of public lands, worthy of funding and management planning. But in the first decades of the twentieth century, the fledgling organization was too busy figuring out what it was meant to do with the almost two hundred million acres of national forest that came under its stewardship.

In the Sierra Forest, Supervisor Charles Shinn, with a minimum of funding and staff, was absorbed with fighting fires and managing timber and grazing permits. Planning for recreation was not on Shinn's plate, although he foresaw the explosion of recreation that would come and recommended

Camping along Bass Lake, circa 1930. Before the construction of the public campgrounds at Bass Lake, people camped indiscriminately next to the lake. This created a situation of overcrowding and prevented day users from enjoying the lake. Camping next to the lake is now prohibited. The formal day-use areas—equipped with tables, barbecues, parking areas and restrooms—attract picnickers, swimmers and fishermen. *Courtesy of the Sierra National Forest.*

developing trails and roads to accommodate the influx of visitors. But it wouldn't be until 1923, under Supervisor Maurice Benedict's watch, that a growing concern for user health and safety prompted the national office to issue its first appropriation for recreation. The State of California received $2,000, which "did little more than provide for a few outhouses," Gene Rose wrote in his book, *Sierra Centennial.* Then, in the 1930s, with President Roosevelt's New Deal, the Civilian Conservation Corps (CCC) came to Bass Lake and constructed the campsites on Forest Service land on the west side of the lake.

Ninety years have passed since that time. Recreation abounds. Federal laws, such as the 1969 National Environmental Protection Act (NEPA), have charged federal agencies with establishing management policies that protect both physical and cultural environments. As a result, the forests-are-open-to-all concept has become established policy, not just the philosophy of Washington politicians and dedicated conservationists. And, yes, people can do as they please—within the scope of the law, prudent use and mutual respect.

To state the obvious, management issues in the forest have gone way beyond the problem of where to place a few outhouses. Things like: how to get an off-highway motorist and a bird watcher to share the same space; what to do when a road being planned crosses over the sacred grounds of a native tribe; why some people should be allowed to carry on with acceptable hunting practices that others judge to be wrong; how to tell members of a family who for generations have been collecting artifacts in the forest that they can no longer do that; why a group cannot be prevented from camping in a public campground just because some people don't like them.

Which is what happened in 1965 at Bass Lake.

Word had gotten around that the Hell's Angels were planning on spending their July Fourth weekend at the Sierra Forest campgrounds at Bass Lake. The Angels had a pretty bad reputation at the time, particularly at Bass Lake due to problems with them in previous years. So there was a great deal of alarm in the community at the prospect of their arrival. The local community and law enforcement joined forces and placed restrictions on where the Angels could go.

The initial response of law enforcement was to issue a temporary restraining order aimed at the Hell's Angels. Prior to the arrival of the group the police set up roadblocks on the routes leading to Bass Lake. When they arrived on their motorcycles—there were two hundred of them—each member was photographed and handed a copy of the injunction, which focused on public law, offensive conduct and possession of weapons. Instead of allowing them to stay at the campgrounds on the west side of the lake, the Forest Service made Willow Cove, an isolated spot on the east side of the lake, available to them. For sanitation, portable toilets were installed. For safety, a ten o'clock curfew was imposed, which meant they were not allowed to leave the campground after that time.

"Nobody wanted them around," said Ray Gallardo, a lifelong resident of Bass Lake who, at that time, was working for the sheriff's department as a special deputy assigned to Bass Lake. None of the local restaurants would serve them, Gallardo explained, but they were welcomed at the Forks "where they practically bought out all of the beer," he said.

Things went pretty smoothly that weekend, according to Gallardo: "We realized that, if you push on someone, they're going to push back." So everyone behaved themselves because no one—not the police, not the Angels, not the locals—wanted a confrontation. When a complaint came in that the Angels were swimming in the nude, Gallardo drove his boat

The Falls Resort, circa 1960. *Courtesy of the Sierra National Forest.*

into the cove to check out the situation. He didn't see signs of offensive behavior. "They kept a pretty tight lid on themselves," he remarked, "they didn't want trouble. There were police all over the place. They paid all their fees for the toilets at the campsite and were nice to talk to. They were just having a good time."

Gallardo admitted that the local teenagers who were curious about the Angels and wanted to hang out with them caused more problems than the Angels themselves. One specific incident involving the Angels and some of the locals occurred at the Falls Resort, a private resort situated at the waterfall where Willow Creek pours into Bass Lake. The Falls Resort was established in 1916 with a special use permit to the owners from the Sierra National Forest. Originally, the resort consisted of a couple cabins, a store and an icehouse. But over the years, after contending with fire, a flood and a collapsed roof from snow, it expanded to include more cabins and a main house with a dance floor upstairs—also used for rollerskating during the summer months—and a bar downstairs.

Ray Gallardo lived down the road from the Forks when he was a little boy. "We used to go there on Saturday mornings to swim," he said, "of course, we'd wait until the water washed out a bit, because you didn't want to slide down the falls with all the beer bottles they threw there Friday night. That

The slide next to the site of the Falls Resort was always popular and continues to be so today. In fall, the reduced water makes it an ideal place for water play. *Courtesy of Marcia P. Freedman.*

The Timber Room Bar at the Falls Resort, circa 1960. *Courtesy of the Sierra National Forest.*

Visitors to the Falls Resort enjoy refreshments on the Falls patio, circa 1960. *Courtesy of the Sierra National Forest.*

A remnant of the Falls Resort patio, 2012. *Courtesy of Marcia P. Freedman.*

was the greatest swimming there was, right in front of the falls. That was our play place—all the way up to double slide." Gallardo said he met his wife at the Falls, where she and her sister ran the soda fountain.

On that particular night in 1965, when the sheriff's department was called in to calm an overcrowded, rowdy situation, Gallardo arrived to find a group of young people partying with the Hell's Angels. They broke it up, but one wonders whether the decision of the Sierra Forest Service to not renew the permit for the Falls Resort when it expired in 1968 was connected to incidents such as the one that occurred with the Hell's Angels. The reasons given by the Forest Service for not renewing were that the traffic at the Falls created a dangerous bottleneck and, perhaps more relevant, that the Saturday night dances were felt to be an inappropriate activity for National Forest support.

Things changed a great deal after 1968. People began spending more leisure time outdoors. According to the 2000–01 U.S. National Recreation Survey, by the end of 2001, 97 percent of Americans were involved in at least one outdoor sport. Presumably a fair proportion of these people flocked to the national forests where vast tracts of some of the most beautiful land in the country were open to them.

With such diversity and sheer numbers, it seems that making management decisions about appropriateness or inappropriateness of an activity would be close to impossible. "It starts with the rules and regulations," explained Linda McPhail, who manages recreation for the Bass Lake District of the Sierra National Forest, "and simple good manners." In her experience, most people want to follow the rules. More than that, "It's a matter of how we want to walk on the land," she said.

A family vacationing at Bass Lake ventures up into the forest. They like it. The next week they return and camp out at Greys Mountain. They swim in Willow Creek, which runs alongside their campsite. Perhaps they fish. They are visited by Forest Service personnel who welcome them, chat about this and that, talk to them about pack-it-in/pack-it-out. Parents teach their children about protecting the environment. Before long they're picking up trash, getting involved. They begin to have a stake in caring for the forest.

A group of gold prospectors gathers for their annual retreat at the Texas Flat Group Campground. They spread out their pans and shovels, their picks and sluice boxes. They inspect each others' equipment, compare for price and efficiency. In the evening they sit around undisturbed by outsiders and tell stories about the time they hit it big or share dreams of being able to quit their day jobs. Daytime finds these modern-day forty-niners spread out along Willow Creek or one of its small branches at the sprawling Texas Flats

A mother and child play alongside Willow Creek. *Courtesy of Marcia P. Freedman.*

Danny Negrete came up to Greys Mountain Campground along Willow Creek for the first time when he was a Boy Scout. After that, he began coming up regularly with friends and family. Then in 1972, he and his wife, Jeanne, started coming up every summer. They knew they wanted to move to the area, but it wasn't until he got his job at the North Fork Mill that they were able to do so. In the photo, Danny is jumping into Willow Creek as his dog looks on, waiting his turn. *Courtesy of Danny and Jeanne Negrete.*

Jeanne Negrete in the 1970s sitting near Willow Creek at Greys Mountain Campground. *Courtesy of Danny and Jeanne Negrete.*

campground. They search until they find a promising spot to begin their digging. After a day's prospecting, they return to their retreat in the forest, maybe disappointed, maybe harboring the secret of a good spot to prospect. When they leave, the campsite is as they found it. They've been doing this for years and want to be welcomed back.

Horse people love the Kelty Meadow Campground just northwest of Texas Flats. The shady, wide-open campsites along Kelty Creek are big enough to accommodate their horse trailers. They even might be lucky enough to get a campsite with a hitching post. Horse people know that their animals like to wallow in the cool mud alongside creeks, threatening the stability of the roots and plants with their weighty bodies. The horses might even poop in the creek if their owners do not take care. Horse people are aware that hikers don't like them, don't like the odor of the manure and the "horse apples" the animals leave on the trails. Some hikers think that horses don't belong in the forest. But they do. It's public land, and they have a right to be there. According to McPhail, most horse people travel into the backcountry wilderness, outside the Willow Creek watershed and away from popular hiking trails.

Off-road vehicle driving has become an increasingly popular pastime in the forest. For a hiker, recreational motorized vehicles may seem, at best, out of place in the serene setting and, at worst, completely unacceptable. But the off-road rider has as much right to be in the forest as the hiker. As McPhail explained, "You can choose to just sit by a tree and feel the earth under you, let the wind blow through your hair, watch for animals. Or you can get on your motorbike, speed down a hill as fast as you can, crash it, get up, dust yourself off and keep going. It's all okay." Not only is it okay, but with the federal regulation set in place in 2005 national forests were also mandated to designate roads, trails and special areas for off-highway vehicles. The new law required a motorized vehicle management plan that includes designating trails, creating maps and creating signage. One of Gallardo's jobs as a summer ranger was to do GPS mapping and put up signs for the trails. These days, hikers encounter off-roaders pretty regularly. "Some people don't want to be near them because they're noisy and don't seem to fit in the forest," said McPhail, "but people have to behave and show respect. And most do."

It's the end of April 2005. Three kayakers drive up the Beasore Road to the Chilkoot Campground. They leave one of their cars, transfer their kayaks to a second car, then drive the four miles to Willow Creek at Greys Mountain Campground. Their goal is to run the three-mile, thousand-foot-drop Willow Creek course, which Paul Martzen in his article "North Fork

Willow Creek—An Adventure," describes as "a classic small steep creek" through the deep canyon between Greys Mountain and Chilkoot. They put in at 5:01 p.m. Martzen refers to starting so late as the first bad decision. He takes notice of the snow at the put-in spot as they push off. The creek churns with the numbing cold snowmelt that pours down from the mountains.

The first part of Martzen's account of the run refers to having a great time, his friend's good run of the big falls at 5:37 p.m. and amazing and beautiful runs. He describes tight, twisty, steep slaloms and a bit of mellow scratching along the hallows between several amazing and very big slides and flumes. Then he starts describing a log jam, gives great detail about hanging on, losing his grip, gasping, a relentless current, being rescued by one of his friends and returning to their car at 9:30 p.m. The question is, do people's rights to pursue their own interests in the forest include putting their lives in danger? Probably yes, but one would guess that if a ranger had come across the threesome at put-in, there might have been some intervention because it did seem like an inappropriate venture.

While most people come from outside the area to play in the forest, mainly in the summer, local residents utilize the forest in all the seasons. The locals have a stake in protecting the land. They know they live next to a natural treasure and are concerned about the condition of the forest. Some residents are recent settlers to the area. Some are descended from families who have lived in the area for generations. Native residents have histories that go back hundreds, even thousands, of years. All feel a sense of ownership. Their identity is connected with the forest, so they take care of it. They have hiked every trail and camped in the most remote reaches of the wilderness. Native residents utilize the plants for their medicine, food and weaving. They conduct sacred rituals on their ancient ceremonial sites. Recreation for local residents includes formation of volunteer groups who clear trash and maintain trails.

Opposite, top: Within the last couple of years, a noticeable change has occurred in the forest. Signs have appeared designating roads as open to or closed to motorized vehicles. "Share the Road" has become a common mantra. The sight of off-road riders passing by, sometimes throwing friendly waves, no longer evokes surprise. Off-road riders seem to be a regular part of the forest scene. *Courtesy of Marcia P. Freedman.*

Opposite, bottom: Hikers love to bring their dogs along on their hikes. Dogs are not restricted from the forest as they are in Yosemite National Park. Here, a hiker crosses Willow Creek with her dog not far behind. *Courtesy of Marcia P. Freedman.*

They attend local watershed meetings and learn about meadow restoration. They join noxious weed removal work parties.

If a family has a history in logging or ranching, or an ancestral story that involves expulsion and cultural disintegration, they might be lugging around generations of resentment and a lingering mistrust of the government that has been passed down to them. Yet, some of them know they have to work with the Forest Service if the forest is to be preserved. And the Forest Service knows it has an obligation to work with the disparate communities.

It is as if a cultural shift has taken place. Issues come up because other types of people are starting to come into the area. People who have used the forest in their own way their whole lives have difficulty adjusting to the newcomers, whose practices may be different and, in some cases, hard to accept. But there are laws now that protect the civil rights and cultures of all people. For instance, if you want to go out and dig for artifacts like you always have, you just can't do that in the forest any more. If you find something on or in the ground, you just leave it there. If you are offended by the hunting style of a certain group, unless they are breaking the law or harming the environment, they cannot be stopped.

Little by little, the Sierra Forest is sending people out into the field who know how to forge relationships. The Tribal Relations Program manager is one of those people. He acts as a conduit in the exchange of information between all Native American tribes and the Forest Service. As the liaison, he has the job of making sure tribal rights and interests are represented in Forest Service management plans. He also has the job of clarifying the role and obligations of the Forest Service to the tribes. He goes out and walks the land, talks to the people and, most of all, acknowledges the cultural trauma experienced by the Native Americans in order to establish the grounding for a working relationship.

The hope of this type of approach is that partnerships will be formed and information shared so that collaborative task forces can work together to establish inclusive management guidelines. If at first the process seems tenuous, trust can be built and liaisons established. Local citizen groups like the Sierra Vista Scenic Byway Association work closely with the Sierra National Forest to present education programs and field trips. The Forest Service involves itself with annual events that commemorate bygone history, events such as the Loggers' Jamboree and the North Fork Powwow.

Linda McPhail sees the Willow Creek watershed as representative not only of the society and how it is changing but also of a typical national forest. "There's everything here someone could or would expect when they go to a national forest," she said, "you have the whole gambit: trails, range

cattle, Native Americans, volunteer groups, logging, hydroelectric, ecological restoration. It even borders a major national park [Yosemite]."

In her article "The State of American Forests," Mila Alvarez wrote that "the forestlands of the United States tell a fascinating story about humankind and its relationship with the land. It is a story of trial and error, of consumption and conservation and of conflict and collaboration. But most of all, it is a story of regrowth, renewal and abundance."

Three Sisters All in a Row

A reservoir, an afterbay and a forebay—three sisters in a chain of hydroelectric lakes created from Willow Creek water. There's Bass Lake, the main reservoir in the system; Manzanita Lake, afterbay to San Joaquin Powerhouse Number Three; and Corrine Lake, forebay to Wishon Powerhouse. Their formal job is managing the flow of water for flood control, power production and irrigation. Their coincidental job is playing host to visitors to the outdoors.

A good illustration of this split personality can be seen at Bass Lake.

In spring, when high runoff from snowmelt and rains expose communities downstream from Bass Lake to potential flooding, PG&E closes the Crane Valley Dam spillway gates. The water is contained except for its release through the powerhouse. The level of the lake begins to rise. By summer, water fills the coves and bays of the lake and laps at its fifteen miles of shoreline. Boats stand moored to docks floating in twenty feet of water, and fishermen drive into inlets and bays that can reach depths of one hundred feet. Then, at the end of the summer when the flow of water in the creeks has slowed, PG&E begins a mandated drawdown of the lake, releasing the water for irrigation downstream.

The annual regulation of the lake level is the legacy of a 1909 settlement between the Miller and Lux Company and the San Joaquin Light and Power Corporation over competing needs for the water of the San Joaquin River and its branches, Willow Creek being one of the largest. Because Miller and Lux owned hundreds of thousands of acres of arable land in the San Joaquin Valley and controlled an extensive network of irrigation canals, it

was able to prevail in its suit against the hydroelectric company. As part of the agreement, San Joaquin Light and Power Corporation was given permission to store water in its reservoirs during the high flow times of spring and summer. In turn, it was required to release the water when the seasonal flow fell. For Bass Lake, this meant that by late fall the water level would be reduced to 50 percent of full and would remain that way until the beginning of April, when the cycle would start again. The oversight of the dates and levels of the drawdown were granted to the Department of Water Reclamation.

The effects of these one-hundred-year-old provisions can be felt to this day. Bass Lake, the reservoir, continues its regulation of the flow of the water. Bass Lake, the recreation hub, adjusts as the levels rise and fall over the seasons.

In summertime, when the water is high, thousands of people visit. They picnic in the day-use areas along the lake and at the beaches. They play in the water and zoom around the four-and-a-half-mile lake in their boats and jet skis. And they fish—mostly before eight o'clock in the morning, when the speed limit is restricted to five miles per hour and it's quiet and calm.

In wintertime, the water has been drawn down, and the docks sit at lake bottom. People stroll along the receded shoreline. Some stand and gaze out at the shrunken lake. Others bring their children to feed the ducks and geese. Occasional optimists search the deserted beaches with metal detectors. And only diehard swimmers would think to enter the frigid waters.

Winter is a good time for fishing at Bass Lake. Years ago, Phil Bartholomew, a local resident and former district fishery biologist with the California Department of Fish and Game, recognized the potential for winter fishing at Bass Lake. He devised a scheme to extend the public ramp at Wishon Cove, making it possible for fishermen to launch their boats in the lowered lake during the winter. "At that time," he explained, "my thought was, if the ramp extension was approved, I would have catchable-sized trout planted in Bass Lake during the winter." The ramp was extended by seventy feet. Since then, it has been customary for the Department of Fish and Game to plant tens of thousands of rainbow trout into the lake over the course of the season, which runs from November to April. Sometimes the locals keep track of when the tank trucks will arrive with their cargo of trout. It's not unusual to find a couple of those early birds at the ramp, ready to throw in their lines as the fish shoot out from the end of metal pipes into the water.

Manzanita Lake is the second in the series of PG&E's Crane Valley hydroelectric lakes. It sits three miles south of Bass Lake in a quiet,

A common sight at Bass Lake in winter is a dock sitting on lake bottom. The dock at the Forks Resort, on the west side of the lake, stretches out along the grass in what would be twenty feet or more of water in summer. The poles along the left side will hold the dock in place as the lake fills and the dock rises. The structure that sits empty at the end of the dock will house paddles and other equipment for those renting boats from the resort. *Courtesy of Marcia P. Freedman.*

This is a sight rarely seen at Bass Lake in winter, not only because of the diehard swimmer—who seems to be enjoying himself immensely—but because of the high level of snow. It must have been quite a winter. *Courtesy of the Sierra National Forest.*

Fishermen launch their boat from the Wishon dock into the lowered Bass Lake. *Courtesy of Marcia P. Freedman.*

The extended boat launch at Wishon Cove. *Courtesy of Marcia P. Freedman.*

undeveloped rural setting, one mile west of the town of North Fork. Manzanita Lake receives its water from two sources out of Bass Lake that run parallel to each other: a flume out of the Crane Valley Powerhouse that connects with the forebay to San Joaquin Powerhouse Number Three and from Willow Creek directly. Manzanita Lake's job is to control the output of water from San Joaquin Powerhouse Number Three. This is a protection against surges or any other force of moving water that might compromise the system downstream. Thus its label: afterbay.

Recreation at Manzanita Lake can be considered low key. There are no resorts or formal campgrounds. Despite this, or perhaps because of it, Manzanita Lake has become a favorite getaway spot, especially for locals who seek the quiet and seclusion and the natural beauty that the small lake and its surroundings offer. With only twenty-six surface acres and an average depth of six-and-a-half feet, Manzanita Lake cannot support recreation similar to Bass Lake. Kayaking and canoeing, wading and picnicking at the developed areas, a leisurely walk around the lake, bird watching, a bicycle ride along the road to North Fork are what people come to Manzanita Lake for. They also come to fish. There are several types of fish in the lake, and the Department of Fish and Game sometimes stocks the lake with rainbow trout. This adds to the appeal of Manzanita Lake as a fishing spot. Those wanting a more adventuresome experience seek the dispersed camp sites in the canyons along Willow Creek, where they can find more challenging hiking trails or can hunt or fish.

Historically, the area around Manzanita Lake has not mirrored the kind of development that took place at Bass Lake and North Fork. Logging and agriculture were not part of its story. Homesteaders and settlers did not establish lasting communities and businesses. There was grazing in the past but there has been none in recent times. No grazing allotments for the area exist in the adjacent Sierra Forest today.

It's the Native Americans who set the region apart from the other two lakes insofar as its use and purpose are concerned. Native populations have resided in the vicinity of Manzanita Lake for thousands of years. Many historic and prehistoric archaeological sites have been identified relating to their presence. Tribal members from the Picayune Rancheria of Chukchansi, the North Fork Mono Rancheria and the North Fork Mono Tribe currently make their homes there. Many of them still gather the abundant traditional plants that grow in the area: willow, manzanita, wormwood, sedge, soaproot, bracken fern, oak. These sit at the core of their culture. Many of the tribal members advocate for protection of their cultural resources and continue

their traditional practices. They use Manzanita Lake for community gatherings and cultural events, in addition to recreation.

Corrine Lake, the third of the sister lakes, has the distinction of being the oldest, the smallest and the most openly hydroelectric of all three of the lakes. To get there, you drive south from North Fork along Auberry Road. After a few miles, from the side of a hill, a ditch appears suddenly. This is the same ditch that brought the North and South Forks of Willow Creek together at their confluence. It is the oldest in the system, dating back to Eastwood and 1897.

You turn onto the Corrine Lake Road and see that the ditch has spilled into a flume that carries the water over a deep gully. You park your car at the end of the flume and watch as the water pours into the continuation of the ditch. There's a lot of water. When it tumbles into the ditch, it turns back on itself and foams before moving on.

For a mile and a half, you walk along a road that at times follows the contour of the ditch and at times veers away from it, only to reappear around a corner. At times, the ditch turns and is funneled into a culvert, then disappears under the road where you stand. The water moves at a good pace. You can hear it as you walk along the road.

Soon you leave the ditch. You pass woodlands of scattered oak, bull pine and manzanita and large rolling grass-covered hills dotted with ancient oak trees. In the distance to the north are the pine-covered hills that mark the beginning of the upslope to the high country. You know the ditch is out there somewhere, either running freely through someone's backyard or burrowed under the earth. All along the road there are little side creeks with culverts and side ditches that capture the runoff, but the hydro-ditch is nowhere in sight.

Then you come around a bend and in the distance Corrine Lake sparkles in the sun. Down the hill the ditch has appeared once again, and the water is flowing toward the lake. PG&E trucks are repairing the road. Soon you are even with the ditch and you walk alongside it, crossing through past workstations with valves and pipes. The penstock appears, half buried in the ground. Ahead you see it emerging at the San Joaquin Powerhouse 1-A, a small cement blockhouse that sits on Corrine Lake. The water from the powerhouse will release into the lake, which will control the flow as it is directed down the 1,400-foot penstocks that lead to the Wishon Powerhouse on Kerckhoff Lake. Fishermen sit at the edge of Corrine Lake, unfazed by the powerhouse and the power lines, the penstocks and the PG&E workers. They are going for the trout, the catfish and whatever else they might come up with.

A Closer Look at...

The Whomping, Weeping, Wise and Wondrous Willow

The poor soul sat singing by a sycamore tree,
Sing all a green willow.
Her hand on her bosom, her head on her knee,
Sing willow, willow, willow
—William Shakespeare

Othello's Desdemona sings a willow song for her lost love. Hamlet's Ophelia climbs into a willow tree and plunges to her death. In an Osage myth, a boy in despair gains strength as he clutches the roots of wise old Grandfather Willow. According to Celtic lore, to avert evil and overcome fear of death, the superstitious carry willow branches, knock on the trunk of a willow tree and plant willows near their homes. The willow can make wishes come true. A person with something on his mind can confess to the willow, and the secret will get trapped in the tangle of its branches. At Harry Potter's Hogwarts School for Witchcraft and Wizardry, the violent Whomping Willow protects a secret passageway below its branches and attacks anyone or anything that ventures too close.

Literary and mythical allusions to the willow have existed since ancient times and are found worldwide. The subjects are as varied as the trees themselves. In writing, the willow is associated with love and loss of love, secrecy and inspiration, death and immortality, renewal, growth and vigor. The willow can affect dreams, predict a marriage, signify a lovers' meeting. A myriad of personal attributes and conditions of life, such as strength and wisdom, fertility and joy, are ascribed to the willow.

It's easy to understand the mystique that has grown up around the willow. There are hundreds of different species, from tall trees to creeping shrubs inches high that spread widely over the ground. The willow can grow with remarkable speed, up to ten feet in a year. Its branches carry the promise of a new tree. Stick a fallen limb into moist ground, even upside down, and it will regenerate. The shallow roots of the willow seek out moisture. In dry settings it has been known to send out huge tough shoots that extend way beyond the spread of the tree's branches. If a willow is cut down, the remaining roots might fight back and send up dozens or even hundreds of sucker shoots. The pioneer willow takes root in barren ground and might be the first woody plant to repopulate areas devastated by fire. Even its flower—the catkin—adds to the allure of the willow. Most catkins are single-sex, with male and female blossoms growing on separate trees. The wind carries the pollen between male and female. The catkin blossom is made up of clusters of tiny flowers that have no petals. When it opens, the flowers poke out in spiky shoots, reminiscent of sea-bottom creatures.

Whereas the willow has stirred the imagination for thousands of years, there is a less fanciful but equally intriguing aspect of the tree that sets it apart: its functionality. The wood in the trunk of the willow tree is too weak and lightweight to be used for lumber or for heating, but the flexible, long branches are well suited to a number of practical uses.

The ancient Egyptians wove willow branches into their wicker furniture. Native tribes made use of willow in their construction projects. The Mono cedar-bark *tonobi*, for example, is built around a framework of willow boughs entwined with grapevines. The Mono also enclosed hot springs and acorn granaries in frames of willow branches. In his account of the Mariposa Battalion's pursuit of the Indians into the forest in the spring of 1851, Bunnell describes willow and grapevine ropes that the natives used to vault over boulders. To this day, the Mono use willow branches in producing their baskets.

Willow branches have also been a source of entertainment and recreation, from crafting whistles to fashioning fishing poles. To make a willow whistle you need only two things: a knife and stick. Get a willow branch with green bark. (Willows love water and are commonly found along streams and ponds—they grow abundantly along Willow Creek throughout the watershed.) The important thing is that you need to be able to slip the bark off the wood without damaging the bark. Try to find a stick at least a third of an inch thick. (For detailed instructions on how to make a willow whistle, go to the website www.instructables.com/id/Willow-Whistle.)

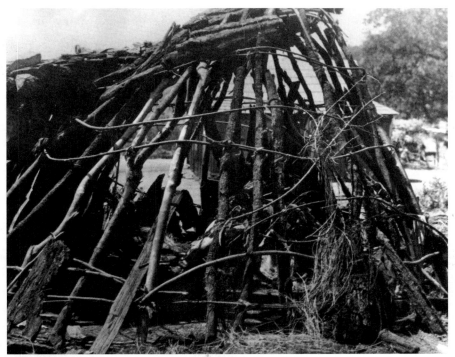

Above: *Tonobi* frame utilizing willow branches. *Courtesy of the Sierra National Forest.*

Left: Willow branches were used by the natives to construct frames over hot springs. When they wanted to capture the heat from the spring for ritual or other purposes, they would drape a cover over the frame, creating a space for sitting within. *Courtesy of the Henry Madden Library at California State University Fresno.*

Diane Bohna recalls times at summer cow camp when as a young girl, she and her siblings used willow branches as fishing poles:

> *We had our twine and wire, our hooks and weights and that was it. So we'd go up to the meadow above the cabin and catch grasshoppers, put them in a jar and poke holes in the top. Then we'd put the jar in the saddlebags with the wire and hooks and twine, and we'd ride out to one of the creeks nearby. Then we'd go to the willows and pick a sturdy branch that was probably about a foot and a half taller than us. We'd cut it with our knife at the bottom and trim off all the branches except for one. That left a kind of fork at the bottom. We put the wire up above the fork and then made the line about as long as the pole. We'd put the weight on it, then the hook, we'd feed a grasshopper on the hook and that was it. We fished in the creek.*

The willow branch is not the only part of the tree that serves a practical end. Willow bark contains a substance called salicin, a compound with analgesic properties. The bark has been used around the world in folk medicine for millennia in the treatment of pain and fever. But it was in ancient Greece at the time of the physician Hippocrates—some three hundred years BCE—that it became part of established medical practice. Written medical documents from that time prescribed willow bark for the treatment of pain, fever and inflammation.

Twelve hundred years later, willow would appear at the forefront of medical science when the French chemist M. Leroux set out to identify the active ingredient in the bark. After a complicated, multi-step process of pulverizing, boiling and filtering the bark, Leroux was able to extract salicin, which the Royal Academy of Sciences in 1831 described as "without contradiction, one of the most important [discoveries] that has been made for many years in pharmaceutical chemistry." By midcentury salicin was being produced synthetically, and by 1899 acetyl salicylic acid appeared on the market and was sold under the name aspirin.

Bibliography

Alvarez, M. *The State of America's Forests*. Bethesda, MD: Society of American Foresters, 2007.

Barnes, Dwight H. *Miners, Lumberjacks and Cowboys: A History of Eastern Madera County*. Oakhurst, CA: Sierra Historic Sites Association, 2001.

Bunnell, Lafayette Houghton. *Discovery of the Yosemite and the Indian War of 1851 Which Led to That Event*. 4th ed. 1911. Reprint. Los Angeles: High Sierra Classics Series, Yosemite Association, CA, 1990.

Eccelston, Robert. "The Mariposa Indian War: 1850–1." *Diaries of Robert Eccelston: The California Gold Rush, Yosemite and the High Sierra*. Frampton C. Gregory, ed. Salt Lake City: University of Utah Press, 1957.

Fowler, F.H. *Hydroelectric power systems of California and their extensions into Oregon and Nevada*. Washington, D.C.: Government Printing Office, 1923.

Giacomazzi, Sharon. *Trails & Tales of Yosemite & the Central Sierra*. Mendocino, CA: Bored Feet Press, 2004.

Goode, Ron. "Gathering Philosophy." *News from Native California* 6, no. 4 (Fall 1992): 8.

Harder, Allen. "Minarets & Western Railway." Speech, Coarsegold Historical Society, Coarsegold, CA, June 1987. Transcribed in *As We Were Told*. Vol. 1. Coarsegold, CA: Coarsegold Historical Society, 1990: 143–6

Igler, David. *Industrial Cowboys: Miller & Lux and the Transformation of the Far West, 1850–1920*. Berkeley: University of California Press, 2001.

Instructables.com/id/Willow-Whistle.

Irigaray, Louis, and Theodore Taylor. *A Shepherd Watches, A Shepherd Sings: Growing Up a Basque Shepherd in California's San Joaquin Valley*. Garden City, NY: Doubleday, 1977.

John Lewis Collection. Special Collection Research Center of the Henry Madden Library. California State University, Fresno.

Johnston, Hank. *Rails to Minarets: The Story of the Sugar Pine Lumber Company*. Corona del Mar, CA: Trans-Anglo Books, 1930.

———. *Thunder in the Mountains*. Corona del Mar, CA: Trans-Anglo Books, 1968.

———. *The Whistles Blow No More: Railroad Logging in the Sierra Nevada, 1874–1942*. Fish Camp, CA: Stauffer Publishing, 1997.

Johnston-Dodds, Kimberly. *Early California Law and Policies Related to California Indians*. California Research Bureau, 2002.

June English Collection. Special Collection Research Center of the Henry Madden Library. California State University, Fresno.

Landlessons.org.

Lee, Gaylen D. *Walking Where We Lived*. Norman: University of Oklahoma Press, 1998.

Low, G.P. "The Fresno Transmission Plan." *Journal of Electricity* 2, no. 4 (1986): 78–89.

Lussac and Majendie. "Salicine—Its Power as a Febrifuge." Section 12 in "Chemical Science." Chap. 2 in "Foreign and Miscellaneous Intelligence."/ *Journal of the Royal Institution of Great Britain*. Vol. 1. London: John Murray, 1831.

Mamet, David. *South of the Northeast Kingdom*. Washington, D.C.: National Geographic Society, 2002.

Martzen, Paul. *North Fork Willow Creek: An Adventure*. Dreamflows Articles. *Dreamflows.com*, May 21, 2005.

Mitchell, Roger, and Loris Mitchell. *Exploring the Sierra Vista National Scenic Byway*. Oakhurst, CA: Track & Trail Publications, 2006.

Rose, Gene. *Reflections of Shaver Lake*. Fresno, CA: Word Dancer Press, 1987.

———. *Sierra Centennial*. Auberry, CA: Three Forests Interpretive Association, 1994.

Scovel, Doris. "The Way It Was." *North Fork Journal*, August 4, 1977.

Shinn, Julia Tyler. "Forgotten Mother of the Sierra: Letters of Julia Tyler Shinn." Introduction and notes by Grace Tompkins Sargent. *California Historical Society Quarterly* 38, no. 3 (September 1959): 157–63, 219–28.

Shinn, Julia T., and Paul G. Redington, ed. "On the Value of a Ranger's Wife." *Sierra Ranger Quarterly Bulletin* (Northfork, CA) (November 1915).

———. "The Ranger's Boss". *Sierra Ranger Quarterly Bulletin* (Northfork, CA) (July 1930).

Steinmeyer, Jurgen. "Pharmacological Basis for the Therapy of Pain and Inflammation with Nonsteroidal Anti-Inflammatory Drugs." *Journal of Arthritis Research and Therapy* 2 (July 2000): 379–85.

Stenzel, Jane, ed. *As We Were Told: An Oral and Written History*. 2 vols. Coarsegold, CA: Coarsegold Historical Society, 1991.

Theodoratus, Dorothea J. "Cultural Resources Overview of the Southern Sierra Nevada: An Ethnographic, Linguistic, Archaeological, and

Historical Study of the Sierra National Forest." Prepared by Infotec Research, Inc. (Susan K. Goldberg, Principal Investigator) and Theooratus Cultural Research, Inc. Dorothea J. Theodoratus, Principal Investigator January 1985.

U.S. Department of Agriculture. National Forest Service. *Off-Highway Vehicle Recreation in the United States and its Regions: A National Report from the National Survey on Recreation and the Environment,* by H. Ken Cordell, Carter J. Betz, Gary T. Green and Becky Stephens. Internet Research Information Series. Athens, GA, and Knoxville, TN, February, 2008.

————. *A Sawmill History of the Sierra National Forest, 1852–1940,* by Bert Hurt. California Region, 1941.

The Way It Was: Photographs & Stories from North Fork's Past. Vol. 1. DVD. North Fork History Group, 2000.

————. Vol. 2. DVD. North Fork History Group, 2002.

————. Vol. 3. DVD. North Fork History Group, 2008.

White, Stewart Edward. *The Cabin.* New York: Doubleday, 1924.

INTERVIEWS

Bartholomew, Phil, in discussion with the author. February 27, 2012.

Bissett Bartholomew, Adele, in discussion with the author. February 27, 2012.

Bissett, Ralph, and Betty Bisset, in discussion with the author. February 3, 2012.

Bohna Crisp, Diana, in discussion with the author. February 2, 2012.

Childers Ozuna, Ardell, Jeanette Ozuna and Blanche Childers, in discussion with the author. January 9, 2012.

Connor, Lois, in discussion with the author. March 29, 2012.

Gallardo, Ray, in discussion with the author. February 23, 2012.

Hebrard, Tom, in discussion with the author. February 16, 2012.

Kennedy, Patrick, in discussion with Virginia Jansen. May 28, 1985. Transcribed in *As We Were Told*. Vol. 1. Coarsegold, CA: Coarsegold Historical Society, 1990: 176–82.

McPhail, Linda, in discussion with the author. November 26, 2012.

Negrete, Danny and Jeanne, in discussion with the author. January 9, 2012.

O'Neal, John, and Harriet O'Neal, transcribed in *As We Were Told*. Vol. 1. Coarsegold, CA: Coarsegold Historical Society, 1990: 273–9.

Potter, Erin, in discussion with the author. April 17, 2012.

Severe, Ron, in discussion with the author. February 23, 2012.

Smith, Aimee, in discussion with the author. October 2, 2012.

Stone, Bayard, in discussion with the author. January 17, 2012.

Stone, Keith, in discussion with the author. March 13, 2012.

Trower, Don, in discussion with the author. February 12, 2012.

Tully Rose, Dulce, in discussion with June English. Transcribed by June English. 1977.

Tully Rose, Dulce, in discussion with Virginia Jansen, Lily Light, and Marylouise Carter. May 17, 1984. Transcribed in *As We Were Told*. Vol. 1. Coarsegold, CA: Coarsegold Historical Society, 1990: 291–5.

Whitley, Robert, in discussion with the author. January 31, 2012.

Williams, Nellie, and Nokomus Turner, in discussion with Lily Light and Virginia Jansen. June 23, 1984 and August 19 and 20, 1987. Transcribed in *As We Were Told*. Vol. 1. Coarsegold, CA: Coarsegold Historical Society, 1990: 364–71.

About the Author

M arcia Penner Freedman, born and raised in the New York Metropolitan Area and later, a resident of Los Angeles for twenty years, has been a lifelong hiker, backpacker and camper. In 1999, she decided to leave city life and relocate to the small town of Oakhurst, just outside of Yosemite National Park. After her move, little by little, Freedman began to encounter Willow Creek. At first it was at the Falls Resort beach at Bass Lake, then while on the popular hike along the creek just above Bass Lake and finally at the picnic sites in the day-use areas on the west side of the lake. When she joined a local hiking group, she met the hydroelectric Willow Creek on hikes along the flumes at Bass Lake and the logging Willow Creek in walks that followed the historic route of the railroad tracks over the Bass Lake Dam. One day, while hiking up in the Sierra Forest, Freedman came across a Willow Creek sign at a bridge. Below, in a ravine, the creek meandered down through the forest and out of sight. Following that encounter, Willow Creek became her focus, an obsession her friends might say, and after years of editing newsletters and immersing herself in other people's interests, she decided it was time to write about something that captivated her: Willow Creek. Freedman received a PhD in educational psychology from the University of Southern California and currently teaches psychology part time at a local community college.